Mexican

ART & CULTURE

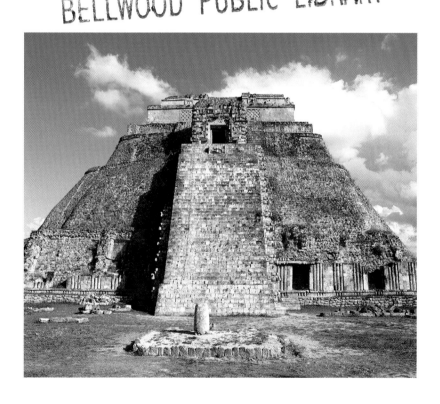

Elizabeth Lewis

 Raintree

Chicago, Illinois

© 2004 Raintree
Published by Raintree, a division of Reed Elsevier, Inc.
Chicago, Illinois
Customer Service: 888-363-4266
Visit our website at www.raintreelibrary.com

For information, address the publisher:
Raintree, 100 N. LaSalle, Suite 1200, Chicago, IL 60602

Printed and bound in China by South China Printing Company

07 06 05 04
10 9 8 7 6 5 4 3 2

Library of Congress Cataloging-in-Publication Data:
Lewis, Elizabeth, 1967-
 Mexican art and culture / Elizabeth Lewis.
 v. cm. -- (World art and culture)
Includes bibliographical references and index.
Contents: Architecture -- Carvings and sculpture -- Pottery -- Textiles and clothes -- Jewelry -- Painting -- Writing, paper, and books -- Music and musical instruments.
 ISBN 0-7398-6610-9 (library binding)
 1. Arts, Mexican--Juvenile literature. [1. Arts, Mexican.] I. Title.
II. Series.
 NX514.A1L48 2004
 709′.72--dc21
 2003001958

Acknowledgments
The publishers would like to thank the following for permission to reproduce photographs:
P. 4 Piers Benatap/Panos; pp. 6 Angel Terry/Alamy; pp. 7, 15 Werner Forman/Corbis; p. 9 Charles Lenars/Corbis; p. 11 Randy Faris/Corbis; p. 13 Ethel Davies/Imagestate/Alamy; pp. 14, 36 Gianni Dagli Orti/Corbis; pp. 17, 18, 25 Panos; p. 19 Carlos Reyes-Manzo/Andes Press Agency; p. 20 Gerald French/Corbis; p. 21 Sue Clark/Alamy; p. 23 Michael T. Sedam/Corbis; p. 24 Charles and Josine Lenars/Corbis; p. 26 David Houser/Corbis; p. 27 Macduff Everton/Corbis; pp. 29, 32, 46 Sergio Dorantes/Corbis; pp. 30, 39 AKG; p. 31 Art Archive; p. 33 Catherine Karnow/Corbis; p. 37 Archivo Icongrafico/Corbis; p. 34 S. Molins/Panos; p. 38 National History Museum Mexico City/Dagli Orti/Art Archive; p. 40 Anna Golden/Andes Press Agency/Alamy; p. 43 Bibliotheque de l'Assemblee Nationale Paris/Mireille Vautier/Art Archive; pp. 42, 51 Danny Lehman/Corbis; p. 44 Tony Morrison/South American Pictures; p. 45 Chris Sharp/South American Pictures; p. 47 Charlotte Lipson/South American Pictures; p. 48 Alamy; p. 49 Sygma/Servin Humberto/Cobis; p. 50 Roderick Johnson/Panos.

Cover photograph of hanging fabrics: Brand X/Punchstock.
Cover photograph of jade funerary mask: Dagli Orti, National Anthropological Museum, Mexico/Art Archive

Every effort has been made to contact copyright holders of any material reproduced in this book. Any omissions will be rectified in subsequent printings if notice is given to the publisher.

The publisher would like to thank Amber Da and Eleanor Wake for their assistance in the preparation of this book.

Some words appear in bold, **like this.** You can find out what they mean by looking in the glossary.

Contents

Introduction

Mexican art reflects the rich mixture of traditions and cultures found in Mexico. There are many different **indigenous** peoples in Mexico who have their own languages and customs and can trace their history back many hundreds of years to peoples such as the Aztecs, Maya, and Toltecs. Today, these traditional groups live alongside people whose ancestors came originally from Europe—particularly from Spain—and there are many *mestizos* (people whose family is a mix of indigenous and European peoples). But these people are all Mexicans and part of North America, and the mix of traditions has formed a country in which almost everyone creates art in some way—you can see it everywhere.

Three important eras

Mexican history can be divided into three main periods. Each one produced its own unique type of art. **Pre-Hispanic** describes the period between 1200 B.C.E. and 1519 C.E. It includes the civilizations of the Olmecs, Maya, Teotihuacán, Toltecs, and Aztecs. Each of these groups produced their own distinctive styles of art. In 1519 Hernán Cortés arrived from Spain and conquered the Aztecs. This is when the **Colonial period** began. Much of the art produced during this time was influenced by Spain. The third period began in 1821, when Mexico won its independence from Spain. The art created since this time reflects the country's renewed sense of pride in a culture and history that is distinct and native to Mexico.

Mexico is a very diverse country made up of many different regions, each producing its own particular type of art.

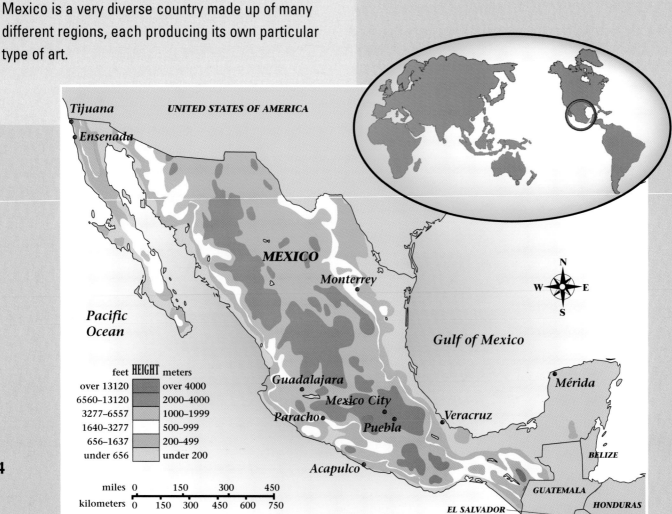

Tijuana

UNITED STATES OF AMERICA

Ensenada

MEXICO

Monterrey

Pacific Ocean

Gulf of Mexico

Mérida

Guadalajara

Mexico City

Veracruz

Paracho

Puebla

Acapulco

BELIZE

GUATEMALA

EL SALVADOR

HONDURAS

feet HEIGHT meters	
over 13120	over 4000
6560–13120	2000–4000
3277–6557	1000–1999
1640–3277	500–999
656–1637	200–499
under 656	under 200

miles 0 150 300 450
kilometers 0 150 300 450 600 750

N W E S

4

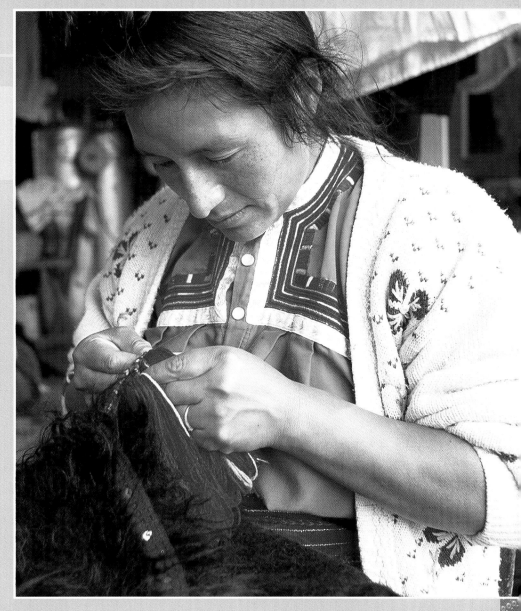

Craftspeople often wear traditional Mexican clothes, particularly in the more rural areas of Mexico.

Many regions

Mexico is made up of many different regions, from deserts in the north to rain forest in the south. In each of these regions live groups of people, each with its own way of life, and often with its own language—there are currently about 50 **Native American** languages spoken in Mexico. From remote mountainous areas to big cities like Mexico City, Mexican life involves a mix of the traditional, which often varies from region to region, and the modern.

North and south

It is important to remember that Mexico is just across the border from the United States—in fact, California, Texas, and Florida were all at one time part of Mexico. Both countries influence each other. By contrast, to the south of Mexico lies Guatemala, a country of mountains and rain forest where the Mayan culture continues to live.

Religion and ritual

Most Mexicans today are Catholic, and much of the art they make reflects their beliefs. Throughout the year, there are many religious festivals for which special pieces of art are made.

Mexico became a Catholic country when the Spanish conquered it. Until then, the people living there had worshiped spirits and gods related to aspects of nature such as the Sun, Moon, and Earth. Their worship involved many special **rituals,** and the people made many artistic images both of their gods and of their rulers, whom they considered godlike.

A wide variety

The existence of so many different regions, languages, foods, and cultures leads to a huge variety of Mexican art. Mexican art uses all sorts of different materials, and artists often choose their raw materials based on what can be found near where they live.

5

An ancient culture

Much of the art that has been produced in Mexico was made hundreds of years ago. A great deal of this art has survived and gives us information about the people who created it.

The Olmecs are one of the oldest known civilizations in the Americas, flourishing between 1200 and 300 B.C.E.. They were particularly good sculptors and carved enormous heads out of rock. One of their favorite subjects to carve was a *werejaguar*, a creature with features that resemble both a human and a jaguar.

Teotihuacán was a city-state in the Valley of Mexico, lying about 25 miles (40 kilometers) northeast of today's Mexico City. During the period from about 100 C.E. to 650 C.E., it was one of the largest cities in the world and was a very powerful and influential cultural center. Its people built incredible monuments such as the Pyramid of the Sun and the Pyramid of the Moon.

The Mayan culture flourished from 300 C.E. to 900 C.E. in the area from the Yucatán **Peninsula** in Mexico to what is now Guatemala, Belize, and Honduras. The Mayan area in Mexico stretched between the modern states of Chiapas and Quintana Roo. The Maya are best known for the amazing cities they built—such as Palenque—with pyramids that had beautiful carvings and painted **murals.**

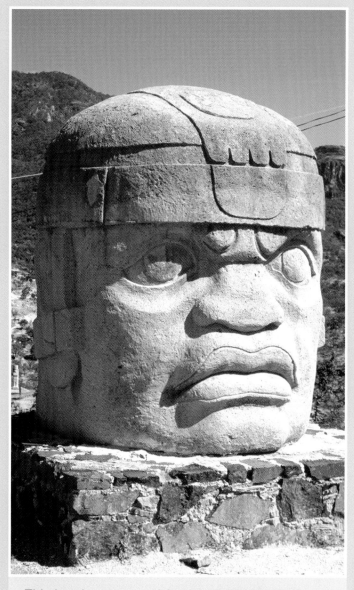

This head was carved from a single block of **basalt** by the Olmecs. There are eighteen heads like this one around Mexico and they can be up to 10 feet (3 meters) tall and weigh up to 30 tons. The helmet is thought to signify royalty.

1200–300 B.C.E.: Olmec civilization flourishes, beginning in the eastern coastal lowlands around the area we now know as Veracruz

c.1150 B.C.E.: The Olmecs carve enormous stone male heads

300 C.E.–900 C.E.: Mayan civilization occupies the area now known as Guatemala, Honduras, and the Yucatán Peninsula

The Toltecs had a very **sophisticated** culture—their name means "master builders." They existed between the 9th and 13th centuries C.E., when they built many pyramid temples in an area called Tula. One of these is known as the Plumed Serpent and was dedicated to the god Quetzalcoatl.

The Aztecs were at their most powerful between the 14th and 16th centuries. They created an immense empire centered on the city of Tenochtitlán, the site of modern Mexico City. They fashioned beautiful art from gold in honor of the sun, one of the gods they worshiped. Spanish soldiers conquered the Aztecs between 1519 and 1521.

The arrival of the Spanish

The Spaniard Hernán Cortés led an expedition to Mexico in 1519. He marched to Tenochtitlán, the Aztec capital, where he was welcomed by Montezuma, the Aztec emperor, who thought Cortés was a god and presented him with a beautiful feathered headdress. Cortés imprisoned Montezuma and conquered the Aztecs in 1521. The period in history that followed is called the **Colonial period.** The **Native Americans** were exploited and treated almost as slaves under the Spanish. Many different social classes were created, depending on where you lived and whether your ancestors were Spanish or Native American. There was much rivalry between these classes, and some were much more powerful than others.

This terra-cotta statue represents a Mayan noble wearing traditional ceremonial dress.

100 C.E.–650 C.E.: The highly developed Teotihuacán civilization flourishes

700 C.E.–1200 C.E.: Teotihuacán declines about 700 C.E., and the people move north to Tula about 10th century C.E.

1325–1519: Aztec civilization begins when the Aztec tribe builds the city of Tenochtitlán, now Mexico City

An important change at this time was that Roman Catholicism became the national religion, rather than the worship of native gods. Much of the art that was made at this time, both by the **Native Americans** and by the descendants of the Spanish colonists, was influenced by the Catholic religion.

Independence and revolution

The **Colonial period** came to an end in 1821, when Mexico won its independence. One of the agreements of the independence treaty was that the Spanish and *criollos* (Mexicans of European descent) were granted equal rights. There then followed a long period of instability, then a period of revolution from 1910 to 1920. A leading figure in the revolution was Emiliano Zapata, who fought for the rights of the rural population. He has become the subject of many legends and ballads in Mexico. The revolution in Mexico was a very disruptive time, and many works of political art were produced, especially in the form of **murals** painted on the outsides of buildings.

Mexico today

Today, Mexico is a country of great contrasts. Many people have moved away from the countryside to the cities, and there is a big difference between living in a Mexican city and living in a remote village. Mexico City is one of the largest cities in the world. However, many Mexicans are very poor. Many have gone to the United States to find work, and, as a result, Mexican art has spread into the culture of the United States, just as U.S. culture has spread to Mexico.

Diego Rivera was famous for painting very striking murals on the outside of public buildings. He wanted to make sure that as many people as possible saw his work and understood his political message.

1492: Christopher Columbus "discovers" the Americas, although Native Americans already inhabited the land

1521: Hernán Cortés conquers the Aztecs, captures the emperor Montezuma, and tears down the city of Tenochtitlán. Mexico City is built over the ruins.

1821: Mexico granted independence from Spain by the Treaty of Córdoba. The Roman Catholic Church becomes the national religion.

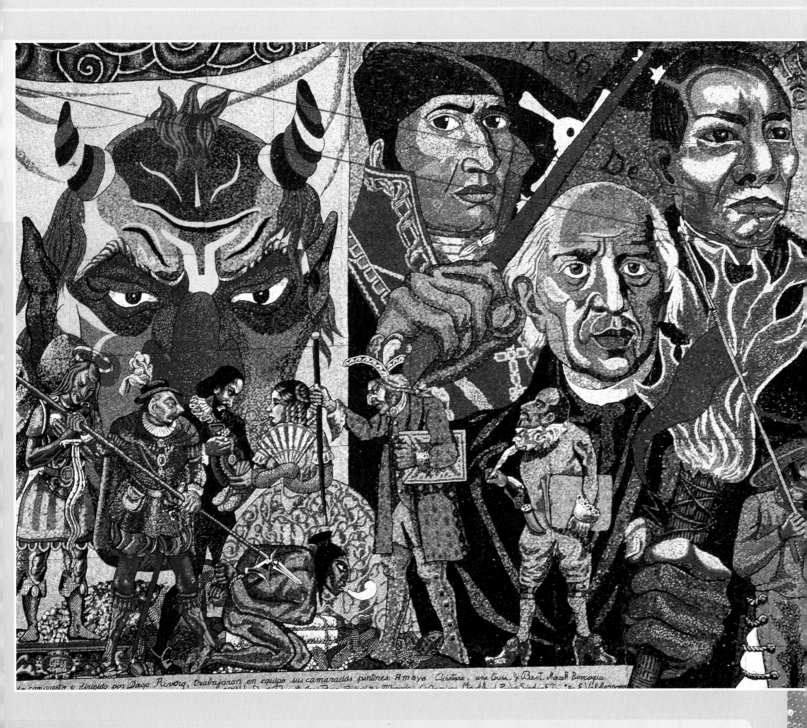

1836: Texas wins independence from Mexico

1845: Texas becomes part of the United States

1846–1848: War with the United States

1910: The Mexican Revolution begins. New laws are introduced and land is returned to Native Americans.

1929: The Revolutionary Party is formed and rules Mexico until 2000

2000: The Revolutionary Party is defeated by Vicente Fox of the National Action Party (PAN)

Architecture

If you travel around Mexico, you will see an enormous variety of architecture. Whenever a new group of people came to power or settled somewhere different, they would make their mark by building palaces or temples in their own particular style. These monuments were all built using tools made out of stone, and all the transporting of the heavy materials was done by hand—until the 20th century no form of lifting machinery was used at all. Today, Mexican architecture is built using all sorts of materials, including glass and aluminum. The designs are very **sophisticated** and are **renowned** throughout the world.

In modern Mexico, most families are quite large, and couples usually have more than one or two children. Most people have migrated, or moved, to the cities, where they live in modern houses. However, a quarter of the population still live in rural villages in simple houses, sometimes made of *adobe* (mud bricks that have been left to dry in the hot sun), wood, or other natural materials. These houses are very similar to the houses that Mexicans lived in centuries ago.

The Pyramid of the Sun in Teotihuacán is one of the largest pyramids in the world. When it was built in about 150 C.E., it would probably have had a flat top with a temple dedicated to the sun god.

Teotihuacán

Teotihuacán was one of the greatest ancient Mexican cities. By about 550 C.E. it is thought to have had a population of 125,000. The biggest structures in Teotihuacán were the Pyramid of the Sun and the Pyramid of the Moon. The Pyramid of the Sun is one of the largest structures to be built in the **Western Hemisphere.** It is made of layers of clay faced with stone and is about 200 feet (61 meters) high. A flight of stairs leads to the summit, or highest point, where a temple to the sun god Uitzilopochtli was originally erected. The pyramid's site was chosen since it is on the axis, or imaginary line down the middle, of the sun's passage during the summer **solstice.** The movement of the Sun, Moon, and stars was important to the religion of ancient Mexican peoples. The walls of temples and some homes were decorated with colorful **frescos.**

 Stelae, ball courts, and palaces

The Maya also built other important stone monuments. Stelae, built as monuments to their leaders, were upright slabs or pillars of stone usually bearing an inscription, a carved sculpture, and the date they were built. Like some other **Native Americans,** the Maya built ball courts. These were areas in a temple where games were played during a ceremony or possibly just for fun. Palaces were built much lower than the pyramids and had lots of rooms, although it is not thought that anyone lived in them, since they were very damp and uncomfortable. They were more likely to have been used for **ritual** purposes.

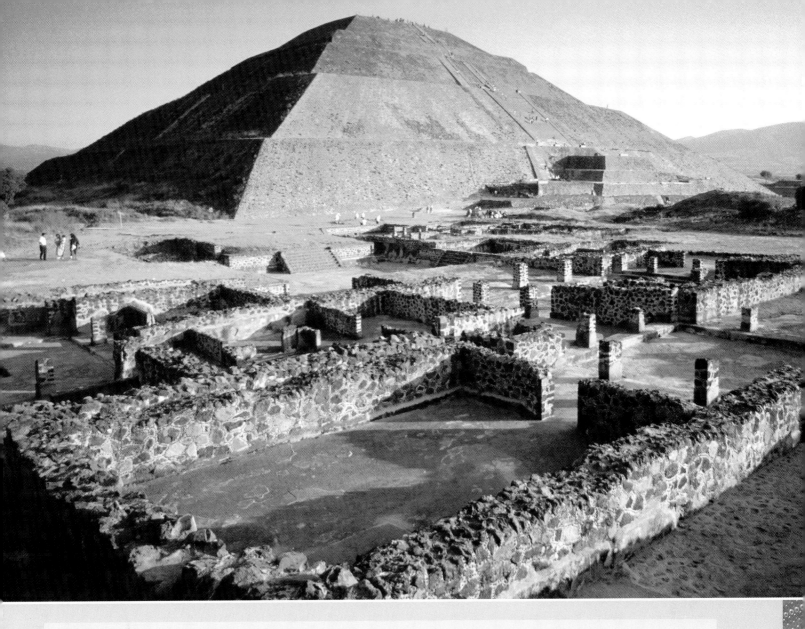

The Maya

The Maya built a great civilization in Central America during the Classic period (between 300 and 900 C.E.). They resided mainly in the south of Mexico, and the main center of their culture was in present-day Guatemala. Mayan art and architecture, and particularly their temples, are the most distinctive hallmarks of their civilization. At Tikal, one of the most important Mayan cities, you can see the remains of the pyramids that the Maya built. These pyramids were used for religious ceremonies and had thatch-roofed temples or altars on the top, where priests performed sacrifices to the gods. Several of the pyramids were grouped around an open **plaza.** The pyramids were quite distinctive because they were built as a series of steps and had a steep stairway built in the middle of one or more of the sides. The steps were made from stone blocks that had been skillfully cut by hand. The foundations of the pyramids were usually made of earth and rubble (broken bits of stone) and were bonded with cement. The interiors were painted with bright colors and the outsides were lavishly decorated with painted sculptures, carved **lintels,** and stone **mosaics.** Another distinctive feature of Mayan architecture was the corbeled arch, or an arch that is held up by two supports (corbels) made out of stone, wood, or bricks.

A developed culture

The Aztecs founded their city at Tenochtitlán, which is the site of modern-day Mexico City. They built the city on a group of small islands in Lake Texcoco, constructing a complicated grid system of streets and canals around a set of pyramids, religious temples, and stunning palaces that could be seen for miles around. They also built an **intricate** series of **causeways** and bridges to connect the city to the mainland. Impressive **aqueducts** were also constructed, and canals were used to transport goods and people.

From the Aztecs to modern Mexico

The Aztecs built a very **sophisticated** and extensive empire between the 14th and 16th centuries. But in 1521 the Spanish explorer Hernán Cortés captured the city of Tenochtitlán and destroyed it. From the ruins he built what we now know as Mexico City. The National Palace, which we can still see today, was built on the same site as the palace of the Aztec emperor Montezuma.

The Spanish **conquistadors** had a great impact on buildings throughout Mexico. This style is called Spanish **colonial** architecture, and one of its distinguishing features is the *Plateresque* style, which was particularly popular in the 16th century. It was a very ornamental style that gave the appearance that silver had been applied to the walls of the buildings.

Mexican architecture also continued to be influenced by **Native American** traditions. Many Spanish colonial buildings were decorated with Native American **motifs.** However, by the 19th and 20th centuries, much of the new architecture in Mexico City resembled the **ornate** style of the French, with heavily decorated, grand buildings.

Renaissance in architecture

Today many of Mexico's cities have wonderful examples of stylish modern buildings. From 1945 onward there has been a **renaissance** in Mexican architecture that has attracted attention from around the world. Architects suddenly became more interested in designing fresh modern buildings rather than strictly copying past styles.

However, new buildings such as the main library of the National Autonomous University of Mexico, built by Juan O'Gorman, incorporate superb **murals** with **frescos** and **mosaics** that are a reminder of the wall paintings of their ancient architectural predecessors. The designs are based on the pictures that can be found in early Central Mexican manuscripts. The university is a fantastic example of the new energy that modern architects are putting into their work. Felix Candela, a Spanish architect who settled in Mexico, created the sports stadium for the 1968 Olympic Games held in Mexico City. He also built several churches, which had very unusual concrete shell designs.

The old and new

Guadalajara, capital of the state of Jalisco, is a wonderful example of a city that combines both traditional and modern styles of architecture. On the city's cathedral is a mural called *The Assumption of the Blessed Virgin* by Bartolomé Esteban Murillo, which is a very well-known piece of Spanish colonial art. However, sitting quite comfortably alongside the traditional styles of building are some very striking examples of **Modernist** architecture.

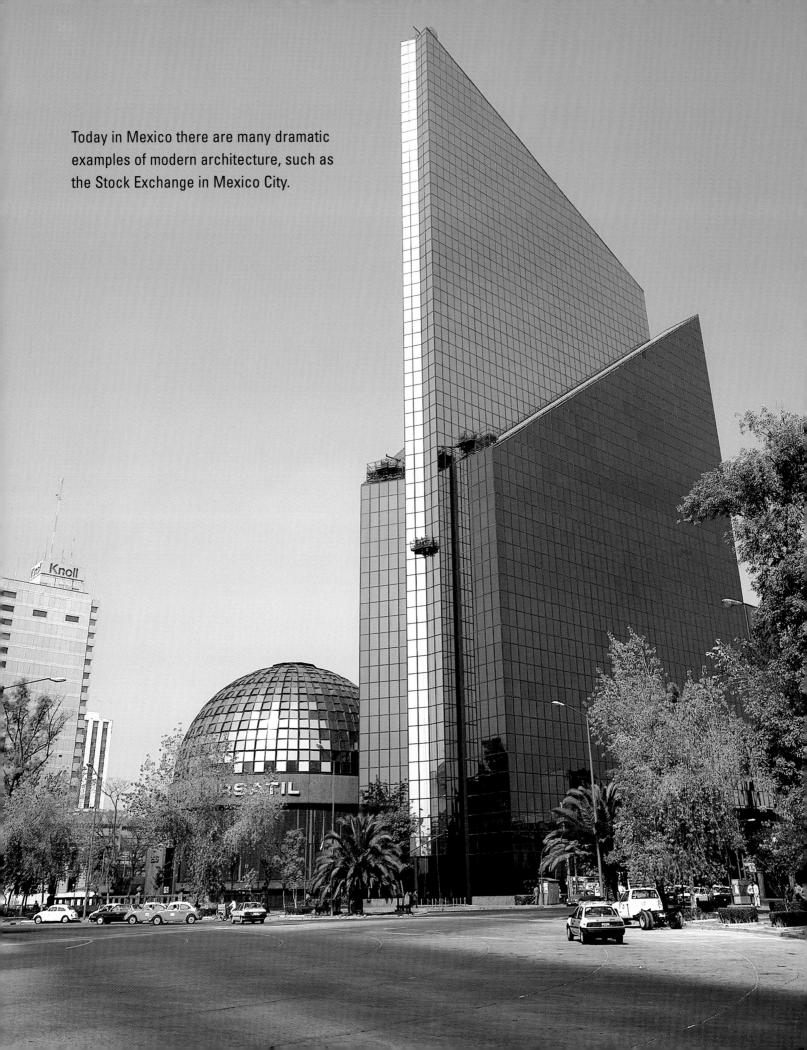

Today in Mexico there are many dramatic examples of modern architecture, such as the Stock Exchange in Mexico City.

Carvings and Sculpture

Unlike some other **artifacts,** carvings often survive relatively intact and can give us important clues about how people lived at the time the carvings were created.

Olmec heads

The Olmecs were the first people in Mexico to build and carve things out of stone. In roughly 1150 B.C.E. they began to carve enormous male heads out of **basalt** near modern-day Veracruz. Some of the heads had helmets and measured up to 12 feet (3.6 meters) high. Why they were carved remains a mystery. In addition to these giant sculptures, the Olmecs carved small statues out of jade, which can be seen in Villahermosa.

The Maya carved many figures out of stone and also created **intricate** carvings in relief.

This means that the figures stood out from the background from which they were carved.

Jade carving

Jade is a hard, green, opaque (not transparent) gemstone that varies in color from dark green to almost white. The Olmec, Aztec, and Mayan civilizations all carved beautiful ceremonial objects out of jade. Axes, knives, masks, and large animal figures were carved in great detail, showing the incredible skill these early craftspeople had achieved. The Maya were particularly attracted to the gemstone, valuing it even more highly than gold. **Archaeologists** have discovered jade carvings inside Mayan burial chambers. It was fashionable for people of high status to have their teeth **inlaid** with decorative jade fillings.

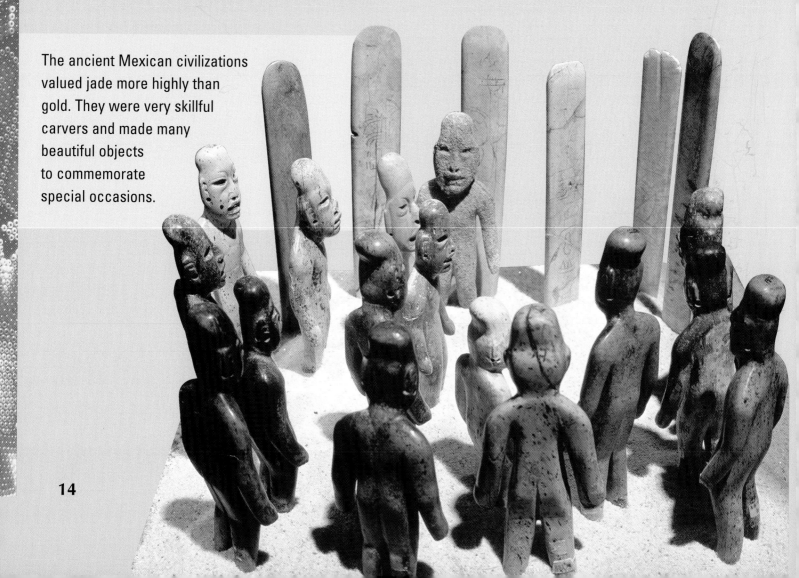

The ancient Mexican civilizations valued jade more highly than gold. They were very skillful carvers and made many beautiful objects to commemorate special occasions.

The Sunstone

The carvings on the Sunstone tell us both what the Aztecs believed about how the world was created and how they measured time. The stone is carved from basalt and it is 3 feet (about 1 meter) thick, 12 feet (3.6 meters) in diameter, and weighs 22 tons. It is thought that the stone was painted in vibrant shades of red, blue, yellow, and white. One of the inner rings is divided into twenty sections—the number of days in each Aztec month. The center of the stone depicts how the Aztecs believed the earth was created. They thought the earth had been created five times, each time lasting for a period known as a "sun." The face in the middle of the stone may represent the fifth sun. The Aztecs believed that the sun needed to be fed, and so they sometimes made human sacrifices to repay the sun for creating life on earth.

The Aztec Sunstone (1427) took 52 years to complete because it is thought to have been carved using stone tools. Placed on top of the main temple in Tenochtitlán, the capital of the Aztec empire, it was lost for 250 years because it was buried by the Spaniards.

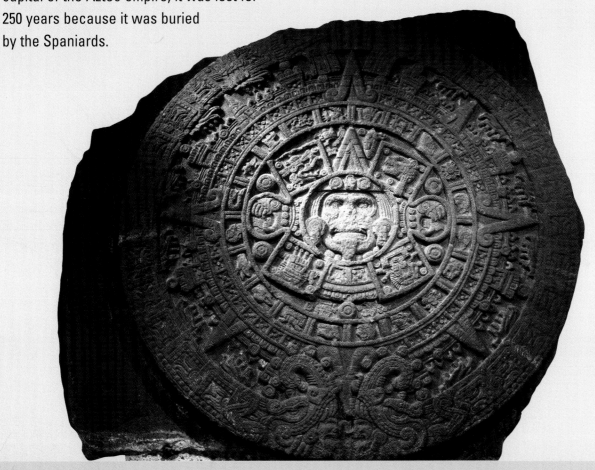

◈ How were the carvings made?

The Aztecs used tools made from **obsidian**, which is a glass-like volcanic stone that is extremely hard and can be even sharper than steel. Because of this, obsidian also made very good weapons—axe heads, knives, and spear points were all carved from this very hard material. It is still used today to make surgical instruments. The Aztecs would use their obsidian tools to sculpt and carve decorative patterns.

Pottery and Ceramics

Modeling objects out of clay has been practiced for thousands of years in Mexico. It is a very skilled art and potters in Mexico have always been much admired. Some of the techniques used by the Aztecs are still being used today, particularly in more rural areas. Modern potters gather their clay from the local area, and they make a lot of their pots by hand or use a wooden wheel that is turned by the potter. Some Mexicans today store their grain and carry their water in large pottery jars just like the Aztecs once did. They also make pots to earn a living. Once a week, village potters set off before dawn for the market, their pots wrapped in dry grasses and corn husks so they do not break.

Historical records

Unlike paper, pottery does not decay, and so it can provide valuable clues about how people lived. Some pieces of pottery have been discovered with detailed scenes painted on them that show people going about their everyday lives. Finding a piece of pottery like this is very exciting for an **archaeologist,** since it tells type of clothes people wore, the animals they kept, and the way they farmed. Pottery can also tell if groups of people communicated. If pottery from two different areas is similar, then it is possible that the two groups met and exchanged ideas.

The **Lancandón** people, who live in Najá, are descended from the Mayan people, and their way of life has changed very little over centuries. Unlike a lot of **indigenous** groups in Mexico, they have not adopted Christianity, and they still make objects out of clay that serve as offerings to their gods. All sorts of things are made out of pottery, from everyday objects like cups and plates to more decorative items such as incense burners, flutes, whistles, and candlesticks.

Specially designed cooking utensils

Mexico is **renowned** for its traditional food. Maize (or corn; used to make **tortillas**), chilies, tomatoes, and beans are all ingredients that have been present in the Mexican diet for centuries. Mexicans have designed special implements to cook their food, and a lot of them were made from clay, a natural resource. They discovered that the secret behind different cooked food flavors was in the clay used to make the cooking utensils. Many of these utensils are still used to prepare food today, and they give Mexican food a distinctive "earthy" taste. The following utensils are all made from clay:

- *Cazuelas* are like casseroles and vary in depth, size, shape, and decoration. They can be used as saucepans, mixing bowls, or baking and serving dishes.
- *Ollas* are pots that give food an authentic flavor when ingredients are blended together. Sauces simmer in the pots to speed up the blending process.
- *Jarros* are pitchers that traditionally have the owner's name painted on before they are **glazed.** They are often used for holding drinking water.

This pottery that has been given a green glaze is distinctly Mexican. All sorts of pottery objects— some practical, some just decorative—can be found throughout the country.

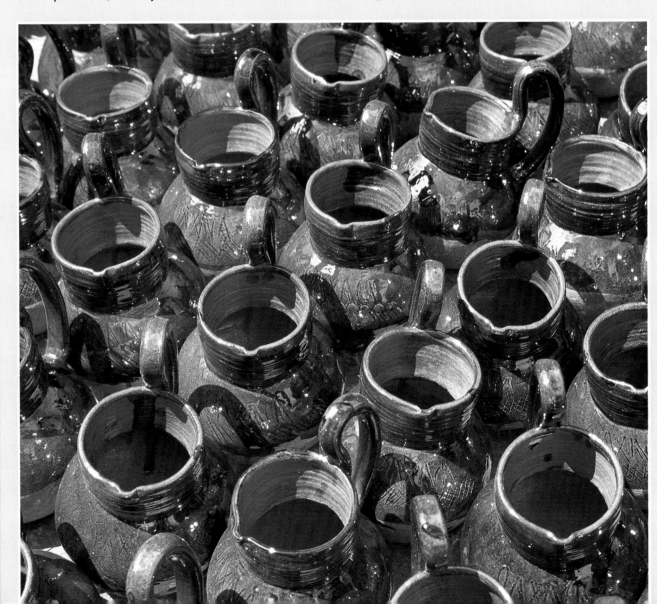

Methods and materials

The methods used to make clay pots vary from region to region. People in some areas are still using the same techniques as their ancestors; others are using more up-to-date methods. In the traditional technique, potters spin the pot around by placing one dish on top of another upturned dish, but more modern techniques use a kick wheel, operated by the foot, that allows the pot to be spun around much faster, leading to a much more **symmetrical** pot.

Puebla is a city famous for its **majolica** earthenware, which is called *talavera*. Much pottery is made in this region because there is a great deal of clay in the earth around the city. Some of the potters still make *talavera* in the same way that the monks did in the 16th century—by treading the clay with their feet. In addition to pots, Puebla is also famous for its brightly colored *azulejos*, tiles that are used to decorate the outside of buildings and kitchens.

Not all pottery is made by hand. In some regions molds are used. But this is not a new invention—the native peoples of Mexico used molds to make their pots in **pre-Hispanic** times, and the same method is still used today. Flat sheets of clay are pressed into or over the mold, which has been sprinkled with ashes to prevent the clay from sticking. Joins between the pieces of clay are smoothed over with the fingers or sometimes a maize (corn) cob.

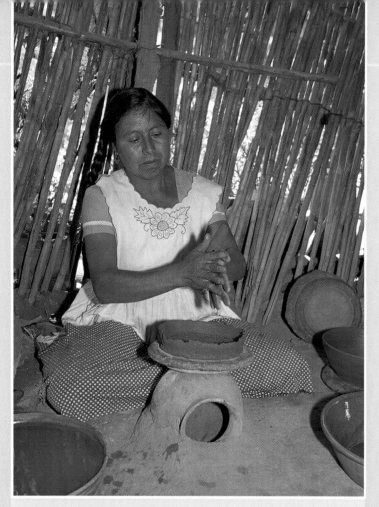

Women in Oaxaca still make cooking pots by hand. The process takes a lot longer than using a mold, but each piece is individual and uniquely decorated.

◈ Oaxacan pottery

In some small villages in Oaxaca, potters prefer the old methods. They hollow out the dark clay with their fists and smooth down the walls of the pot with a piece of broken pottery. A piece of wet leather is used to make the lip of the pot flare out. The women, who are in charge of decorating the pots, scratch beautiful **motifs** on the sides using their nails, or sometimes they might make a more elaborate pattern by scratching a design with a twig or feather.

Some original uses

As with a lot of other Mexican arts and crafts, particular celebrations have led to the making of certain pieces of pottery. Some potters in Jalisco spend all year making nativity scenes out of pottery to sell at Christmas time. These *nacimientos* depict a scene of the Christmas story and can take up the whole side of a room. Some potters specialize in gigantic candelabra (large candlesticks with many branches) known as "trees of life," that are specially made for wedding couples. They are painted in bright colors and most show scenes from the Bible, although some imaginative potters have included Batman in their trees!

In Metepec the *Arbol de la Vida,* or tree of life, has been made for more than 100 years. Originally the theme was the Garden of Eden, but today all sorts of stories are told, even autobiographical ones telling the potter's or the customer's story. Generally the *arboles,* or tree stories, are "read" from bottom to top.

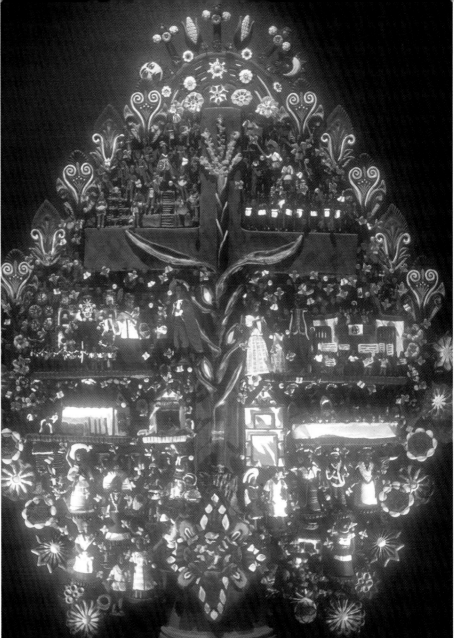

A relatively new development is the **glazing** of the pots. This gives the pots a shiny surface. You can often tell where a pot has come from by the color of its glaze. Black and amber glazes are popular in many regions, and a green glaze is especially common in the state of Michoacán. Many different materials are used to make the glazes that decorate the pots. Some are found locally, but others, such as tin, may be imported. In San Bartolo, Oaxaca, they produce a famous black clay called *barro negro.* Buff and brown ceramics tend to be found in the deserts, and red-brown colors called redware come from Michoacán and the areas around the mountains.

Majolica is a special type of glaze, made using tin, that has been made in Mexico since the time of the Spanish invasion. At that time it was used in the production of beautiful tiles to decorate the fronts of churches.

Textiles and Clothing

Mexican clothing is very colorful and distinctive. It is easy to spot a piece of clothing that is typically Mexican. Many Mexicans, particularly those in rural areas, wear the same style of clothes their ancestors wore before the

Spanish arrived; it is their way of showing their origins. Typical items of clothing include the *huipil*, which is a woman's sleeveless tunic, often with **intricate** embroidered flowers around the neck; the *quechquemitl*, a small triangular cape worn around the shoulders by women; and the *serape*, a blanket with an opening for the head, often worn by men to keep them warm when they are riding horses. Of course, not all Mexicans wear traditional dress. Many dress in modern fashions and might only wear traditional clothing for special festivals.

Many Mexicans, particularly those who live in more-remote areas away from big towns and cities, wear brightly colored, traditional clothes very similar to those worn by their ancestors.

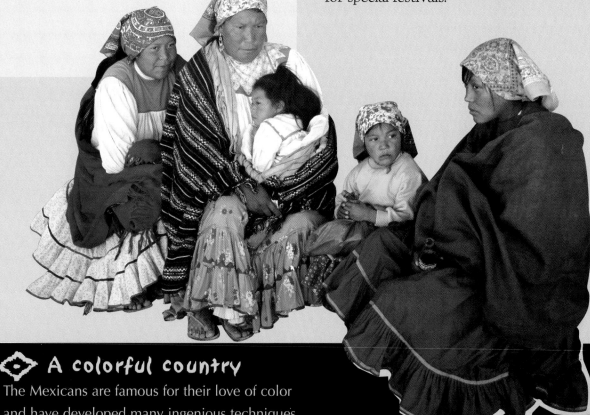

◈ A colorful country

The Mexicans are famous for their love of color and have developed many ingenious techniques for dyeing their cloth. Traditionally, weavers use natural dyes to make their colors, although they are beginning to use **synthetic** dyes. Considerable skill and hard work is needed to achieve the right colors, and the process can take several days. Fruits, flowers, leaves, barks, and woods are used to dye the materials. Blackberries make a lovely purple, camomile leaves a greenish gold, and cochineal, from the cochineal beetle, makes a distinctive red—although the beetle is now becoming quite rare.

Clothing and culture

For many Mexicans their clothes are important symbols, rather than just items to keep them warm or dry. Women and girls can be seen wearing wraparound skirts and a simple top called a *huipil*, and the men might wear palm hats and a tunic called a *colera*. Women often make clothes by hand for themselves and their families, using traditional techniques that have remained the same for hundreds of years. They spend many hours carefully creating the cloth for their clothes. When they die, their **spindle** and needle and thread are buried with them, because they believe they will need them to mend their clothes in the next world.

It is not just women who wear traditional clothes. Mexican men are also proud of their heritage and can be seen wearing very **ornate** outfits, particularly at celebrations. During festivals, when Mexican horsemen (*charros*) are displaying the skills of their horses, they wear elaborate belt buckles and silver ornaments on their large felt hats called *chapetas*. In many rural areas, the men sport traditional palm hats that are useful for protecting their heads from the sun. In some villages, these hats are decorated with ribbons, feathers, beaded bands, colorful woolen pom-poms, and even squirrel tails or beer-bottle caps—anything that is bright, decorative, and easily obtained is used.

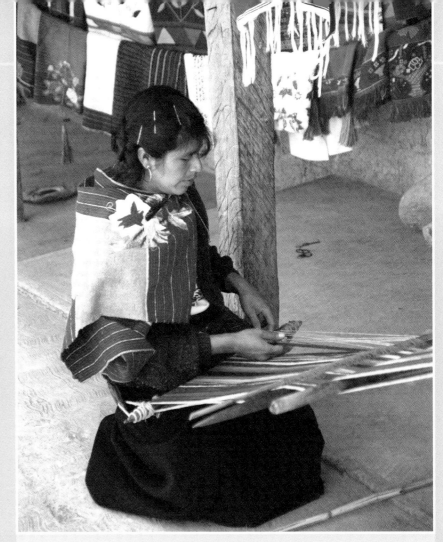

Weaving on a backstrap loom is a very old Mexican tradition. It is usually done outdoors, with one end of the loom fixed to a tree or pillar and the other tied around the weaver's body.

◈ Weaving technique

To weave cloth, it is necessary to combine the warp (vertical threads) and the weft (horizontal threads). In Mexico, this has been done for over 4,000 years using something called a backstrap loom. This simple apparatus is usually used outdoors, with one end tied around a tree and the leather back strap tied to the weaver, who controls the tension of the warp with her body. Blankets, shawls known as *rebozos*, shoulder bags, sashes, skirts, rugs, and tapestries are all made on the backstrap loom.

A very distinctive pattern

Each region in Mexico has its own particular style of dress and special weaving patterns. A Mexican could tell you where somebody comes from by looking at the design of their *serape* or their **poncho,** a garment resembling a blanket with a slit for the head. For example, a blanket with a rainbow pattern means the wearer comes from the Saltillo area of Mexico.

Many of today's textile arts are practiced by women. They spend many hours weaving, spinning, or making embroidery, mostly by hand, to create distinctive pieces of clothing that are recognized all over the world.

Animal skins and plants

Techniques that the ancient people used to make clothes are still practiced—crafts such as tie-dyeing, tapestry, quilting, and weaving are all very popular.

The ancient peoples made their clothes from materials that they could find around them. There are ancient **murals** that show men wearing tunics and short cloaks made from jaguar skins. Some of them are wearing very elaborate headdresses made from colorful feathers, which make them look like wild animals and gods. (They wanted to look as important and frightening as possible.) They also wore headdresses made from husks of maize, or corn on the cob, a crop grown all over Mexico.

Only the noblemen of the ancient civilizations were allowed to wear cotton, since it was very expensive. The lower classes had to wear material that was less comfortable. The Aztecs used to make some of their cloth from fibrous plants. One type, now called *henequen,* was made from the maguey plant. They also used the bark of wild fig and other trees to get fibers that they could then weave into cloth.

Embroidery

The art of embroidery increased in popularity after the Spanish arrived. Today these skills are handed down from mother to daughter. The traditional designs are recorded on samplers (pieces of cloth that have been framed with all the different stitches sewn onto them). Mothers use these samplers to teach their children the stitches—and there are many to learn. All the different stitches are used to personalize either a home-woven piece of cloth or a piece of material that has been bought in a shop. Satin-stitch is one of the most popular stitches. The stitches are made very close to each other, making sure there is no material in between, to create the effect of a piece of satin. Animal, bird, and flower designs created using this stitch decorate *huipiles,* skirts, and blouses.

The Huichol people, who live in a remote mountainous area of Mexico, are best known for their colorful yarn pictures. The embroideries contain many religious symbols such as the Dog Woman, whom they believed was the first woman in the world, created from the skin of a dog.

◈ Car-tire shoes

Mexicans today are as inventive as they have always been in their use of craft materials. *Huaraches* are sandals that are worn all over Mexico. The soles are made of rubber from used car tires! They are a good example of recycling materials, and they are also very comfortable.

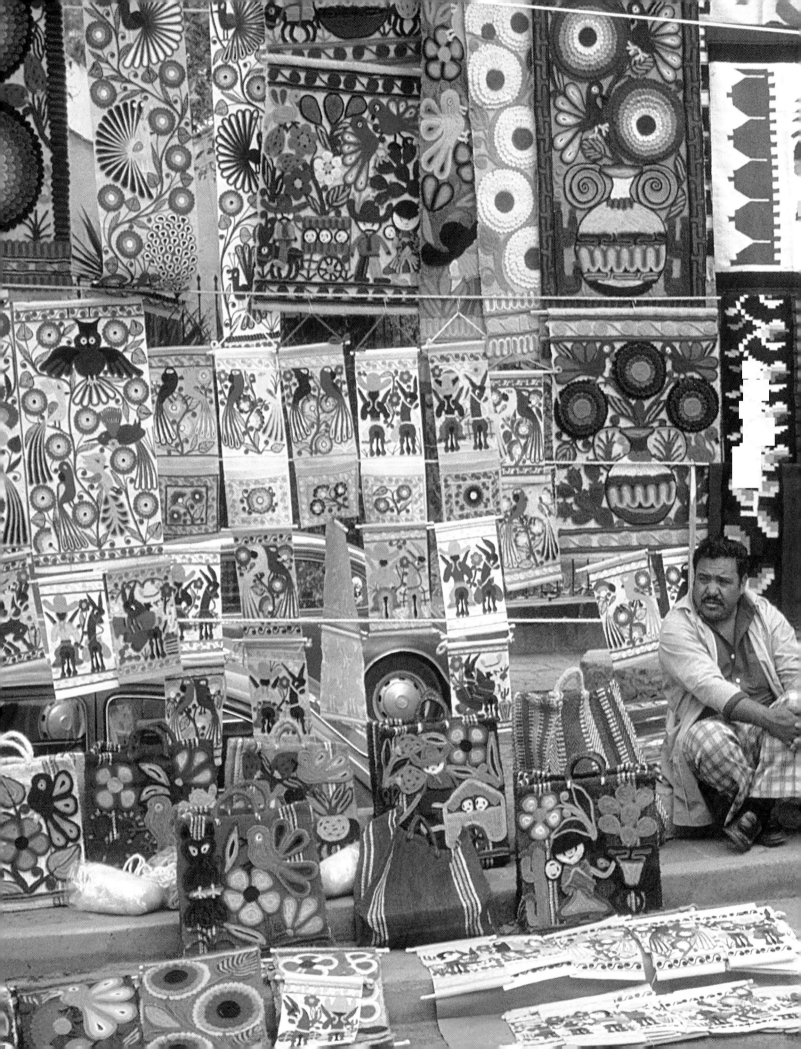

Jewelry and Adornment

Anything worn to decorate the body can be considered jewelry. In ancient times jewelry was worn to show how important someone was or to symbolize his or her religious beliefs. Jewelry does not have to be made out of a precious material like diamonds or gold. In fact, all kinds of materials—shells, bones, feathers, or even hair—can be made into jewelry.

Gold and silver

Before the Spanish invaded Mexico in 1519, gold was everywhere, and the people were very skillful in making jewelry from it. The art of metalwork spread from the Andes mountains in South America north to Mexico. The **artisans** would melt the gold down and pour it into **intricate casts** to make impressive pieces of jewelry. Golden masks and chest ornaments were particularly popular. The Aztecs had an advanced knowledge of metalworking techniques, and they organized themselves into separate guilds to create their work.

When the Spanish arrived, they were amazed not only at the amount of gold they found but also at how little the native people valued it. The Aztecs prized the gold because it was the same color as the sun, which they worshiped, not because it was a financially valuable metal.

A large amount of the silver mined every year comes from Mexico. In Taxco, in the state of Guerrero, hundreds of silversmiths make silver jewelry from this soft metal and sell it around the world. Silver earrings are particularly popular in Mexico, where babies' ears are often pierced soon after they are born. Silver crescent-shaped earrings called *arracadas* are typically Mexican. They are often **filigree,** which is fine silver wire that has been twisted into a delicate lacy pattern.

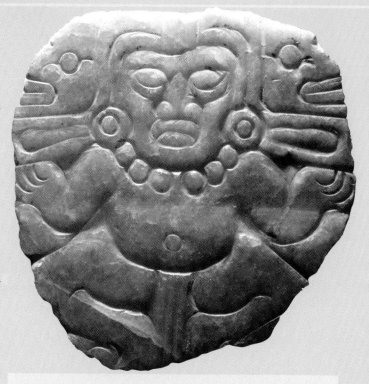

This jade ornament would probably have been worn by someone very important, such as a priest or a person of nobility.

Today, when the *charros* (Mexican horsemen) dress up for a festival, they wear pants with solid gold buttons down the sides and belt buckles, stirrups, and spurs **inlaid** with silver.

Precious stones

Mexico is rich in minerals and precious stones. Turquoise, **obsidian,** onyx, amethyst, and jade are plentiful. In Chiapas, pieces of amber—a fossilized resin (a sticky substance from trees) often containing insects—are tied on cords around children's necks to protect them.

The Maya valued jade more highly than gold and made **pendants,** bracelets, and masks from this green gemstone. When someone died, a jade bead was placed in the person's mouth, along with other items that they would find useful in the **afterlife.** The Aztecs also practiced this custom.

Featherwork

In the Aztec region of Anahuac, feather workers commanded as much respect as goldsmiths. They lived in a special quarter of the city and made capes, shields, and headdresses for the noblemen. They attached the feathers using paste and a needle and thread. Today, the dancers who perform *La Danza de los Concheros* during festivals carry feathered shields and wear feathered headdresses, just as their ancestors once did.

Other materials

In Taxco, in the state of Guerrero, jewelers make beautiful pieces of jewelry out of abalone shell, which is valued for its iridescent—or shiny, rainbowlike—color. Cow horn and tortoiseshell are used to make elaborate hair combs, carved in the shape of horses, crocodiles, or mermaids.

Montezuma's headdress

When Hernán Cortés, the Spanish explorer, arrived in Mexico in 1519, the Aztec emperor Montezuma presented him with a magnificent headdress, since they thought he was a god. The headdress was made out of long green feathers, jade, and gold beads. The brilliantly colored feathers were from the quetzal, a bird the Aztecs saw as sacred.

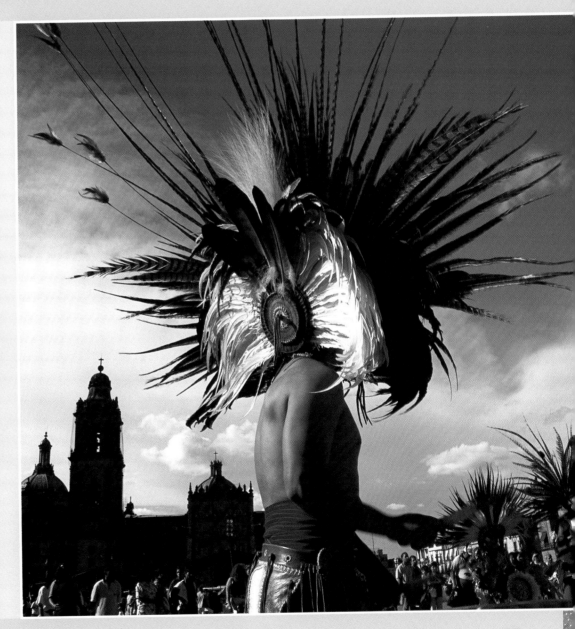

During festival time, Mexican people dress up in traditional costumes such as this elaborate headdress, which is probably similar to the one worn by Montezuma, the Aztec emperor.

Displaying your beliefs

People choose to decorate their body for all sorts of reasons. Which jewelry they choose to wear and how they wear it can tell us a lot about their beliefs and the culture from which they come.

The **Huichol** are one of Mexico's **indigenous** people who live in one of the most remote parts of the country. They are a very religious group and show their beliefs through the clothes and jewelry they wear. They are very fond of glass beads and like to wear them as necklaces or threaded on a net as a hatband, belt, or shoulder bag. The beads are arranged in patterns that are very symbolic to the group. For example, they believe the pattern of an eagle will guard the growing maize (corn) crop, and a zigzag pattern symbolizes the rain.

The **Otomí** people also believe the things they wear will protect them. They hang tiny beaded sachets of herbs around their necks to protect them from diseases.

Jewelry instead of money

After the Spanish brought them to Mexico, glass beads were sometimes used to buy things instead of gold and silver. Today, glass beads are still valuable as heirlooms that are handed down from mother to daughter. In Najá you can see young girls weighed down with as many glass-bead necklaces as they can possibly wear.

In the **Zapotec** area of the Oaxaca valley, the jewelry the women wear is very valuable. The women invest a lot of money in their earrings and necklaces. During festivals, the women like to wear all their jewelry. Chokers, bracelets, earrings, and heavy coin necklaces dipped in gold or silver are proudly worn to show how wealthy they are.

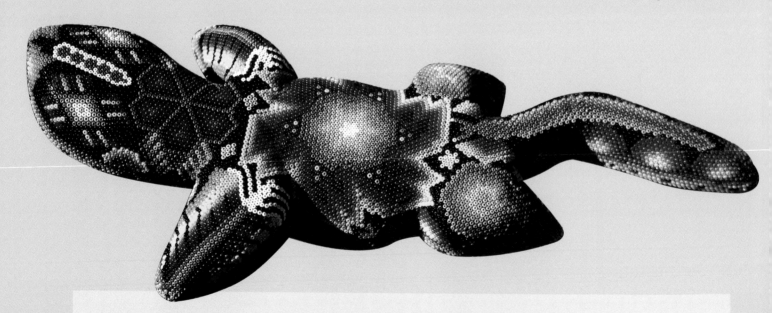

The Huichol group that lives in Jalisco is famous for patterned glass beadwork. Huichol beadwork is considered a high form of craftsmanship and requires great skill. In this design, thousands of tiny beads are used.

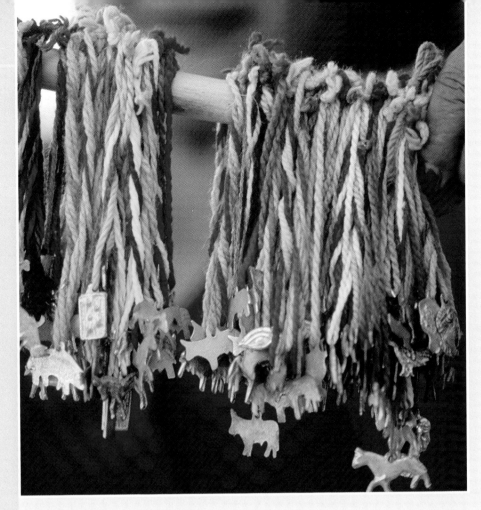

Throughout Mexico, silver coin necklaces and *milagros* make popular pieces of jewelry for people to buy.

Jewelry and religion

In the Yucatán the women wear long, golden **rosaries** and golden **filigree** crosses during festivals to display their faith. Jewelers are often asked to make *milagros*, which means "miracles" in Spanish. People offer them to their favorite patron saint when they are hoping for a cure, or as a thank-you if their prayers have been answered. They ask the jeweler to make them something in the shape of the part of the body that is to be cured—for example, a leg, arm, or eye. *Milagros* can be made out of gold, silver, tin, wood, or even bone and wax. They are either worn as jewelry or attached to statues of the saints or to walls of churches.

Body art

The Maya practiced tattooing, creating **intricate** patterns on their bodies for spiritual reasons. A tattoo is a permanent design that is made on the body by piercing the skin and putting ink inside. Because having a tattoo was very painful, it was seen as a sign of bravery and courage. The Maya practiced all sorts of body art—full-body tattoos, facial tattoos, scarifications, body paint, and piercings. The colors were very symbolic: Warriors were tattooed in red and black; young men were painted black until they married; priests and those who were about to be sacrificed were tattooed in blue; and prisoners were given black and white stripes.

Lacquering

When a wooden object is **lacquered**, it is given a shiny, hard coat so that it is possible to eat or drink from it. In Mexico, all sorts of things are lacquered—trays, boxes, dishes, and trunks are all lavishly decorated. Creating the shiny coat takes a long time, often up to several days. A special paste is painted on, and when this has dried it is polished with a soft cloth before another layer of paste is added. The wood that is used can be scented, and sometimes part of the wood is left bare to allow the fragrance of the wood to come through. Some of the most popular objects lacquered are **gourds.** These are natural fruits or vegetables that can be made into bowls or cups to eat and drink from. Because lacquering takes such a long time, in some areas of Mexico today gloss paint is being used instead.

There are generally two types of lacquer decoration commonly found in Mexico today: *rayada* (which is engraved) and *pincel* (which is painted).

The *rayada* technique

In this technique, powdered gray soil is added to the base black lacquer and the artist uses a special tool made out of a thorn to scratch out the design. The thorn is taken from a local thorn tree and inserted into a feather. The scratching reveals the black layer underneath, and many **intricate** patterns are made by the artist. When the desired design is completed, the piece is then ready to be painted in bright colors.

The *pincel* technique

This technique involves painting detailed designs over the black lacquer layer. Each artist has his or her own technique, but often the painted design is raised slightly above the black layer to give the surface a nice texture. The paint is applied using a *pincel*, which is a tool made from cat hairs that have been tied together and inserted into a feather. Because the cat hairs are so fine, the artist can paint very intricate designs. The colored paints are made from powdered **pigments.** Different colors are added to white powder, and a natural oil is added to make a thick paste.

 ## A long process

Before the lacquer is applied, the surface has to be sanded down so that it is perfectly clean and smooth. The lacquer is made from minerals and oils. A black powder called the *tizate* is made by grinding and baking the minerals calcium carbonate and magnesium. The *tizate* is then mixed with natural oils—it is this process that makes the lacquer hard and waterproof. The oils are obtained from plants, seeds, and insects. The gathering of the oils is a highly specialized task and requires detailed knowledge of the local natural resources. The quality of the *tizate* and oils is very important to the end appearance of the lacquer. The piece is then ready to be decorated.

Gourds

Gourds have been used in Mexico since ancient times. A gourd is made from a large fruit or vegetable such as a squash or a pumpkin. The gourds are cut down from the tree and left to dry in the sun. When the gourd is hard and dry, it is cut down the middle and left in water until the insides rot. The flesh of the gourd is then soft enough to be scooped out. Because the gourd has been left to harden first before its flesh is scooped out, it keeps its shape. Once the gourd has been hollowed out, it is then ready to be decorated. One of the most popular methods is lacquering.

Gourds are used for all sorts of things. Traditionally they are used for drinking, and in some parts of Mexico people still drink a hot drink called *atole* from gourds. (*Atole* is a corn-meal gruel that is drunk with chili pepper, usually as the first meal of the day.) Apparently drinking *atole* from a gourd makes it taste much better than drinking it out of plastic. In the north of Mexico, gourds are used as bottles with a maize (corn) cob used as a stopper. In the more rural areas, the rind of the fruit from the calabash tree makes good bowls from which to eat. They can also be used as strainers, made into musical instruments or handbags, or even worn on the head to protect the wearer from the sun.

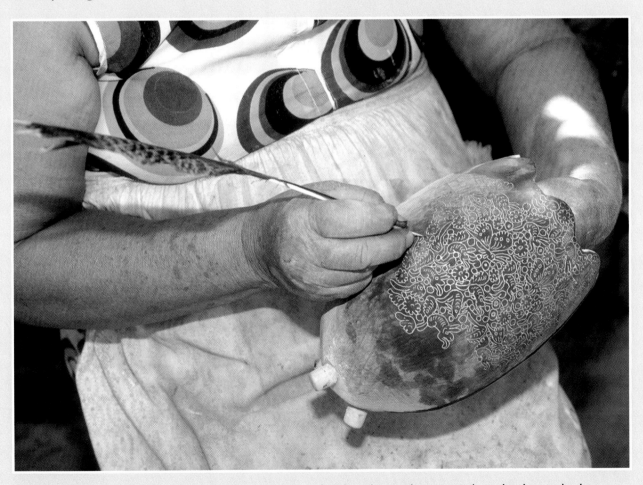

A special tool, made from a thorn inserted into a feather, is used to scratch an intricate design on the lacquer of this gourd before it is painted with bright colors and metallic dyes.

Masks

Masks have been worn in Mexico since ancient times. Some of the early Mexican peoples believed that everyone has two souls—one in the head and one in the heart. By covering your face with a mask they believed you would be able to get in touch with the spirit world. Today masks are mainly used as a disguise to entertain audiences at festivals.

Regional dances, ceremonies, and masks

Masks are usually worn for part of a festival or during a special dance. They are used to help tell a story, to entertain people, or to make fun of important people with a **caricature**. They can be made out of all sorts of materials. The Maya made masks for their special ceremonies out of jade, which at the time was a very precious stone, even more valuable than gold.

The fair skin, blue eyes, and facial hair of the European **conquistadors** fascinated the native peoples of Mexico, whose features were very different. These new faces inspired them to create masks showing the Europeans' distinctive features. The masks were intended to make fun of the Spanish and their fine clothing, beards, fair skin, and often arrogant manner.

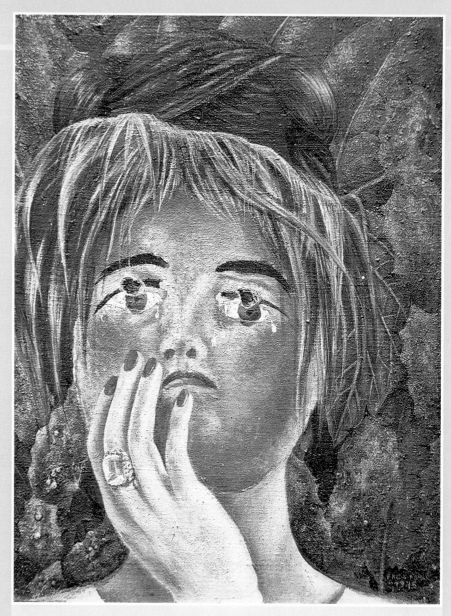

The artist Frida Kahlo can be seen holding a sad mask to her own face in this painting from 1945 called *The Mask*.

Masks in paintings

Masks remain very important in Mexican culture and often appear in the paintings of the 20th-century artist Frida Kahlo. Many of her self-portraits show her face as a mask under which she is hiding her true feelings. In *The Mask*, painted in 1945, this idea is reversed. Here the artist is holding a papier mâché mask up to her face. This time it is the mask that is showing her feelings, since it appears to be crying, while she hides her actual face.

Masks and dancing

There are many festivals in Mexico, and they vary from region to region. Each festival usually has its own particular dance, which often has a religious significance. The dancers often wear wooden masks that are beautifully decorated. The dancers have to take a vow to promise God and the saints that they will perform the dance for a certain number of years.

In San Pablo Apetatitlán, during carnival time, the villagers dance the Dandies' quadrille (a kind of square dance). Each dancer wears a wooden mask that has been painted with oil paints and then rubbed with a dead chicken, which is thought to protect the surface of the mask and make it shiny. The masks have glass eyes, which are attached to a thread that opens and shuts them. Although wood is the most popular material for making masks, leather, clay, papier mâché, **gourds,** and wax are also used.

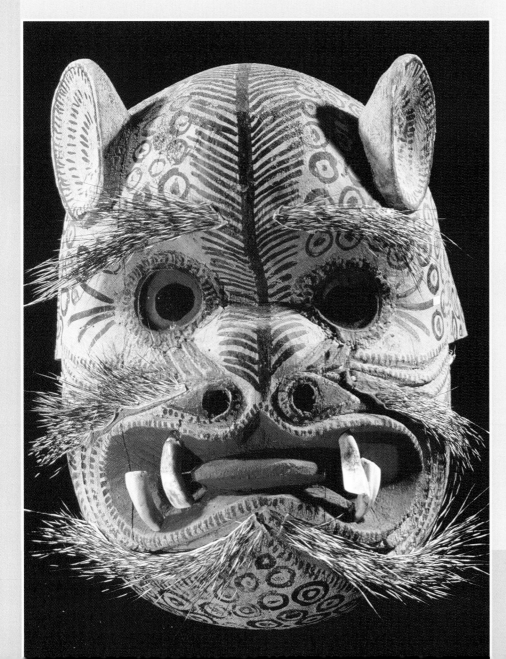

The "tiger dance" is a very old dance, dating back to ancient times. Since there are no tigers in Mexico, these dances probably originally featured jaguars or ocelots (a kind of wildcat). They show the tiger damaging the crops and being chased away by angry farmers. The tiger masks are made of wood and have real animals' teeth, hair, and whiskers. They are often worn by children during the Day of the Dead festival (see page 34).

31

Fiestas and Festivals

Mexico is a country that takes its festivals very seriously. Some, like Independence Day, are celebrated throughout the country, whereas some are celebrated only in certain regions. At festival times, **artisans** make special objects for people to buy to decorate their homes and churches in celebration of these occasions. Mexico is a Roman Catholic country, and much of the art that is created is connected with this religion.

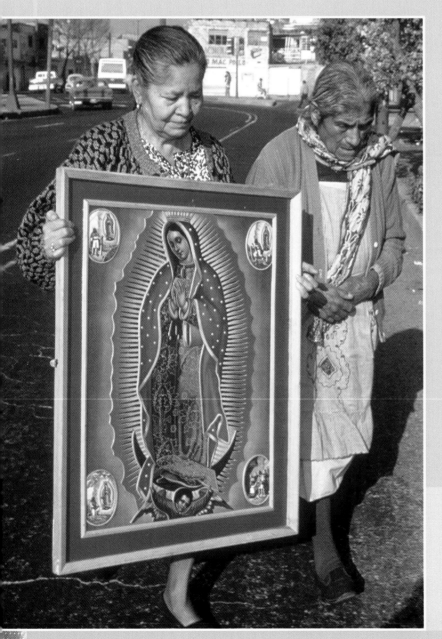

Religion and art

On December 12 Mexicans celebrate the feast of the Virgin of Guadalupe, who is the patron saint of Mexico. The day celebrates the story of how the Virgin Mary appeared to a poor boy named Juan Diego. On this day, many people make a **pilgrimage** to the Virgin's shrine. The children dress up in traditional **Native American** dress and visit their churches. Little girls wear colorful necklaces, embroidered blouses, and patterned shawls, and the boys wear serapes, sandals, and painted moustaches and are called *Dieguitos,* after Juan Diego. On their backs the children carry little wooden frames from which hang all sorts of Mexican crafts such as tiny clay pots and **gourds.** The Virgin of Guadalupe is an extremely popular **icon** that has inspired a great deal of art, and many artists make painted sculptures of her.

At Christmas some regions stage *las posadas,* a Spanish word meaning inns or shelters. Usually on Christmas Eve, people will take to the streets and reenact the journey made by Mary and Joseph to Bethlehem. Sometimes people dress up as the couple, but often children carry candles and elaborately carved wooden figures of Mary and Joseph on a donkey. The parties go from door to door asking for shelter. Often they are refused, until finally one house welcomes them in. Here,

The Virgin of Guadalupe is a very inspiring image for many Mexican artists. Pictures, statues, and ornaments are all created in her honor. People take images of the Virgin to be blessed after mass.

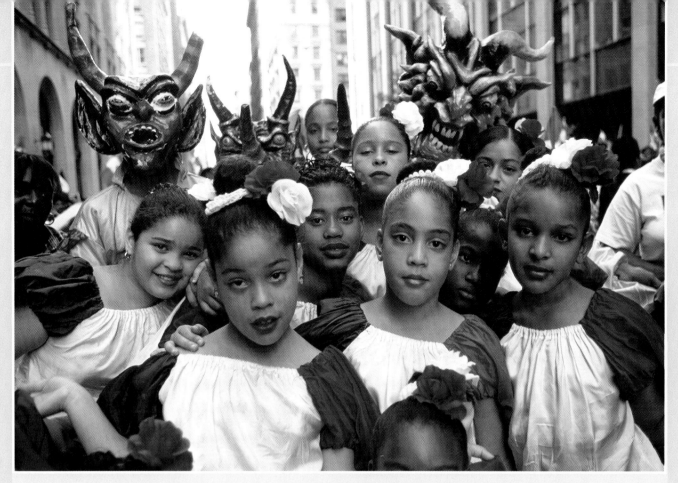

Cinco de Mayo is an important day in the Mexican calendar. People dress up in traditional costumes and take to the streets in celebration across Mexico and in Mexican communities in other countries. This parade is in New York City.

they will be given Mexican chocolate and Christmas Eve *tamales,* which are corn husks, stuffed with chilies and tomatoes. At the end of the festival children are allowed to break the **piñata,** a papier mâché toy that has been filled with toys and candies.

Independence and revolution

September 16 is the day Mexicans celebrate their independence from Spain. Papier mâché helmets and trumpets are made in red, white, and green, the colors of the Mexican flag. *Rehiletes* are sold, which are like the feathered shuttlecocks used in badminton on long sticks, painted in the national colors. Traditional food and drink is served. Every **plaza** in every town is covered with flags, balloons, and strings of lights, and fireworks are lit.

Many Mexicans believe Independence Day should really be celebrated on the May 5 (*"Cinco de Mayo"),* the day they defeated the French army at the Battle of Puebla in 1862. Every year on this day the people of Mexico celebrate. There is **mariachi** music, traditional foods, bullfights, and colorful decorations. The women dress up as *soldaderas,* the women who traveled with the army to cook and care for the men, while the men reenact the battle between the French and the Mexicans. At the end of the festivities, fireworks are set off to celebrate the Mexican victory.

Deaths and Burials

In many parts of the world, death is something that is not spoken about a great deal. In Mexico, however, death is not such a forbidden subject. Family and friends who have died are remembered openly and their lives are frequently celebrated by those who miss them. Consequently, many of the arts and crafts in Mexico have to do with death. There are even children's toys that make fun of death.

El Día de los Muertos

El Día de los Muertos means "the Day of the Dead" in Spanish. It is held every year on November 2 and is the most important festival in Mexico. On this day, people remember their relatives and friends who have died, placing lighted candles and flowers on their graves. Many Mexicans stay up all night to remember those who have died. Mexicans believe the dead come back to the earth on this day, and so they cook the favorite food of their loved ones who have died and place it on their graves or on household altars for them to eat. Many of the items that are made to celebrate the Day of the Dead have a lot of humor in them and are designed to make people laugh. Throughout the year in Mexico, toymakers spend their time making the things they are going to sell for the Day of the Dead. These are enjoyed as much by the adults as by the children.

An important part of the Day of the Dead celebrations is the acceptance and mockery of death. This is shown by the *calavera,* or skeletons that can be seen everywhere during the festival in all sorts of funny poses. They were inspired by José Guadalupe Posada, a 19th-century Mexican artist and political cartoonist. He liked to draw skulls and skeletons to show how short life is and to make death seem less serious to the living. In his drawings he showed that whether someone is a peasant or a politician, in death we are all the same. His drawings, always in black and white, often depicted poor people and their suffering.

Skulls and skeletons

As November approaches, all the shops begin to fill up with toy coffins, cardboard skeletons whose legs are attached to strings, wooden merry-go-rounds with little skeletons on horses, and clay skulls with movable lower jaws. The windows of bread shops are painted with dancing skeletons, and inside they sell *panes de muertos,* which means the "bread of the dead." These are little figures made from bread dough that are sold all over Mexico. In Toluca they make skulls out of colored sugar and marzipan guitars filled with aniseed liquid (used for flavoring) as gifts for the living and for the dead. In Oaxaca they make tiny clay skeletons of wedding couples, priests, soccer players, and policemen.

The Day of the Dead festival inspires Mexicans to create skulls and skeletons from a wide range of unusual materials.

35

Painting

Painting in Mexico has a long history, and the earliest important examples date from the time of the Maya. At Bonampak in southern Mexico, several building interiors are decorated with brightly painted **murals.** These murals, painted using the **fresco** technique, provide important information about the everyday life of the Maya. Some include scenes of dancers and musicians, while others show battle and torture. Often the drawings are outlined in black and filled in with brightly colored **pigments.**

Other important examples of Mexican painting come from the city of Teotihuacan, where temples, homes, and other buildings were covered in murals. Although many of these paintings had to do with religion, they give important information about the social organization of the society. The relative sizes of people and objects and what they are wearing give clues about their importance.

Mystery of the Mayan blue

The colors used in the murals at Bonampak are particularly interesting, and **archaeologists** have been able to work out how the Maya created the colors—all except one. The red and pink pigments were created from red iron oxide; the yellow, from hydrous iron oxide; and the black from carbon. Athough we know it is made from clay and indigo, no one is quite sure *how* the blue was made.

The murals at Bonampak are important because they show in detail how the Maya lived—the clothes they wore, the battles they fought, and the customs they followed.

New rulers, new styles

After the conquest of Mexico by the Spaniards in 1521, Mexican painting changed dramatically. There were two main reasons for this. First, the Spaniards came from a rich tradition of painting in Europe, where the Italian **Renaissance** was changing the way that artists looked at their subjects. Second, the Spaniards brought their Roman Catholic beliefs to Mexico, and so much of the art produced after their arrival was concerned with Catholic themes.

During the first years after the Spanish conquest, some of the most important artists working in Mexico were actually foreigners. These artists, such as Baltazar de Echave and Andrés de la Concha, brought European techniques and subjects to Mexico. However, the Spanish also made use of the talents of native artists, often retraining them in Renaissance techniques. The work of these artists can be seen in hundreds of churches and monasteries built by the Spanish.

An original genre

While most Mexican art at this time was heavily influenced by Spanish traditions, one original genre did develop: the **caste** painting. During the **Colonial period** there was intermarriage between Mexicans and the Spanish administrators. The caste paintings, which were often taken back to Spain as souvenirs, claimed to show what the offspring of various racial mixes would look like. They each show a mother and father of different races with their child. These paintings were meant to be insulting, and are an example of the racist attitudes of the Spanish toward their Mexican subjects. However, the caste paintings are important because they are some of the only pieces of art from that period that show Mexicans from all walks of life.

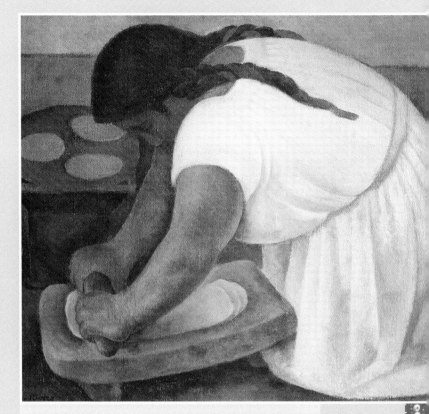

Diego Rivera liked to paint people carrying out traditional Mexican skills, as in *La Molendara* ("The Grinder"), which depicts a woman rolling out tortillas.

Independence

For several decades after Mexico gained its independence in 1821, painting continued to follow European styles. It was not until the late 19th century that Mexican painting really began to develop its own features. Artists such as José Mariá Obregón began to mix **indigenous** and European subject matter. Also during this time, José Mariá Velasco was painting his unique landscapes. Then, after the turn of the 20th century, Mexican painting came onto the world stage, thanks to two artists: Diego Rivera and Frida Kahlo.

Similar ideas, different approaches

Diego Rivera traveled to Europe at age 21 to study the great works of Western art. When he saw **Renaissance frescos** in Italy, he knew he had found his style. Rivera believed passionately in the rights of the working classes and did not like the idea of paintings that hang only in galleries or the homes of the wealthy—rather, he wanted everyone to be able to see his work. He began painting **murals** on the walls of public buildings, where passersby would see them. His favorite subjects were scenes of ordinary Mexicans doing traditional activities (see page 37). He also painted many scenes of the Aztecs and the revolution against the Spanish.

Frida Kahlo, who married Rivera, also loved Mexico and its traditions. She had a difficult life—a bus accident as a teenager left her in constant pain, and her relationship with Rivera was often stormy—and her paintings reflect this. She used many images from traditional Mexican folk art, and her paintings often had a dark tone. She painted many self-portraits, often using masks or showing herself poised between two different worlds (see page 30).

A rich tradition

It was not just Rivera and Kahlo who were helping to make Mexican art popular throughout the world. Many other artists were exploring

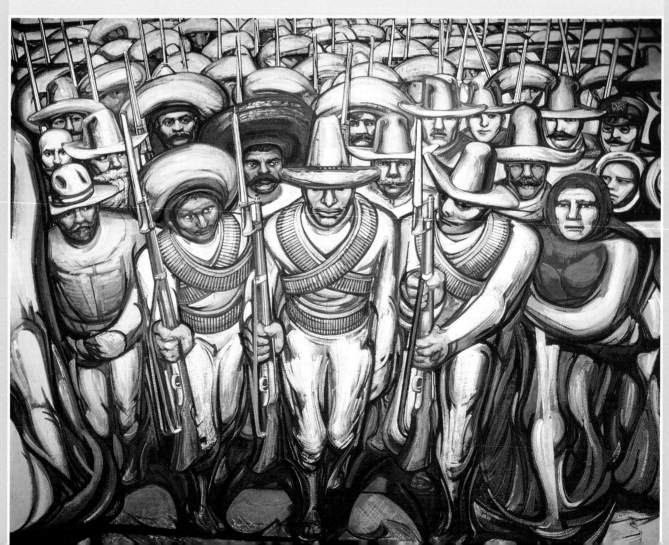

This fresco by David Alfaro Siquieros is called *People's Army*. It is a powerful image of the Mexican people preparing to fight the United States to reclaim the land that had been taken from them.

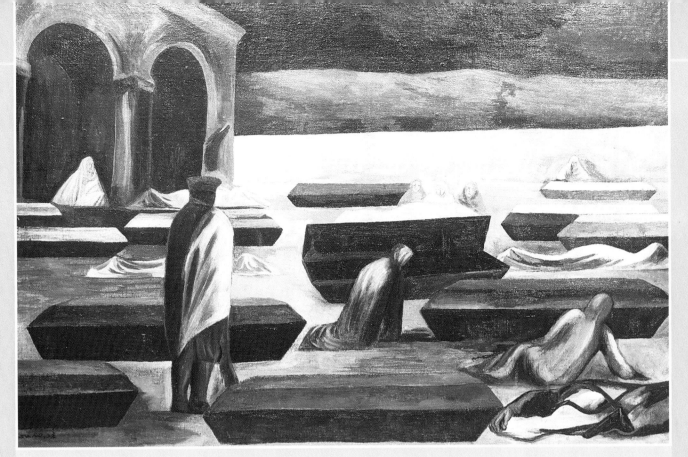

The Cemetery was painted in 1931 by José Clemente Orozco. He was a very political artist whose work was concerned with the plight of the Mexican people. When he was a child he met the renowned painter José Guadalupe Posada, who inspired him to become an artist.

similar themes and styles. Several of them were influenced by the work of José Guadalupe Posada, who died in 1913.

Like Rivera, many Mexican painters of the early 20th century were muralists. Their work was sometimes very political, which upset the government. These painters protested against the government and went on marches to campaign for the ideas in they believed in. They hoped that by painting directly on walls their message would reach as many people as possible, people who would then want to join their cause. Some of these painters, like David Alfaro Siquieros, were sent to prison because of their beliefs.

José Clemente Orozco was a muralist who painted huge frescos showing the poor people of Mexico struggling to survive as they went about their everyday lives. His later work became influenced by **Expressionism;** he began to use fewer colors and to rely on light to show the emotion in the painting.

Another artist, Rufino Tamayo, often painted Mexican people engaged in traditional activities. His paintings are a mixture of traditions from **pre-Hispanic** Mexican art and more modern art from Europe. He was heavily influenced by **Cubism,** especially the works of the Spanish artist Pablo Picasso.

Toys

Toys are very important in Mexico. There are some cities, such as Santa Cruz de las Huertas or Jalisco, that are famous because of the toys they produce. Originally the word *toy* described not just a child's plaything, but also anything that was small and collectible. In Mexico, many adults like to collect miniature ornaments that are often very similar to toys. Although Mexican children today play with the same types of toys as children around the world do, simple handmade toys are still very popular, and the craft of making them is handed down from generation to generation. All sorts of things are used to create unusual toys, especially natural materials that can be found locally such as paper, wood, leaves, clay, and tin, rather than human-made plastics.

Puppets, dolls, and pottery animals

Making and selling toys can be a way to earn a living in Mexico, just as it is anywhere else. Some children are taught from a very young age how to work with clay so they can make toys and earn money for their families. Children as young as seven make carefully modeled pottery animals such as dragons, snakes, armadillos, and peacocks. Puppets are also very popular in Mexico. In other parts of the world puppets are often used to tell fairy tales such as Hansel and Gretel, but in Mexico, puppets are used for more political purposes. There is a famous puppet named Vale Coyote who was a villainous character used to make fun of the dictator Porfirio Diaz during the revolution.

As in the rest of the world, dolls are a favorite toy for Mexican children. They can be made out of all sorts of things, from papier mâché to pieces of rags. Some are brightly painted and others are dressed in traditional costumes.

Musical toys are widespread. Clay whistles in the shape of an animal, black pottery flutes, and white-striped clay trumpets are all popular toys, as are miniature, child-sized guitars.

Festival toys

Special toys are made for certain festivals in Mexico. For the Feast of Corpus Christi, which takes place in June, people give each other a *mulita*, or mule, to celebrate the day. They can be made out of palm leaves, rushes, banana wood, or even the dried husks of corn. Some are small enough to wear as a brooch, while others are large enough to carry a child. On this day many of these toy mules are lined up for sale outside the cathedrals in Mexico, with their **panniers** filled with flowers and fruit. They are a reminder of the real mules that used to wait outside the churches for their owners.

Puppet theater

Leandro Rosete Aranda created a very famous puppet company in Mexico City. In 1900 his theater had a cast of more than 5,000 puppets! Audiences would come from all over the country to see famous puppets dance to the music of a live orchestra. Today, the puppets are still made with clay heads, arms, and feet that are painted and decorated with brightly colored feathers.

The bodies and heads of these puppets are made of clay, but other local materials such as grasses, straw, and wood are used to decorate the puppets. In addition to depicting traditional stories, puppets are often used to make fun of leading political figures. Because they are puppets and not live actors, the stories they tell can be a lot more daring.

Paper

Mexicans have always been very creative in their use of paper. The Aztecs developed their own style of picture writing, which consisted of a series of pictures describing a religious or historical event. They wrote these down on paper made out of bark or on deer skin. These writings are called **codices,** and they tell us a great deal about the Aztecs. The codices often show the deeds of gods and rulers or tell stories of battles. Bark paper is still very popular in Mexico today, particularly with the tourists who like to buy a traditional painting as a souvenir. Unfortunately, this has led to a shortage of the bark needed to create the paper.

◈ Making bark paper

Women are responsible for making the paper. There are two types of tree that are used. The fig tree gives a dark paper and the mulberry tree a whitish paper. The bark is peeled off the tree, washed, then boiled in a cauldron for several hours. The cleaned, softened fibers are laid in lines on a board and beaten with a stone until they fuse together. The paper is left in the sun to dry. Mexicans still record the happenings of village life on bark paper in a style that is similar to that used on the ancient codices.

Bark paintings such as this one are handmade by the Otomí Indians using the same method that was used in the 13th century. Very colorful birds or animals are painted on the paper.

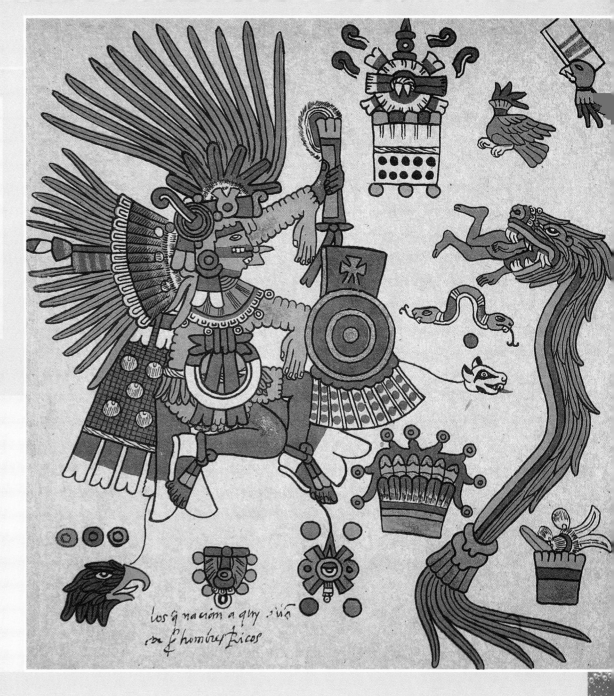

Specially trained scribes wrote the Aztec codices using natural dyes on animal skin, bark paper from the bark of a fig tree, or on cotton. This example shows the Aztec gods Xipe Totec and Quetzalcoatl, the plumed serpent.

Cutting out paper

Cutting pictures out of paper is a favorite craft in some areas of Mexico. In the **Otomí** village San Pablito, Puebla, the people still believe in spirits, just as the Aztecs did. They cut the Spirit of the Tomato and the Spirit of the Banana out of bark paper to encourage their crops to grow. These paper seed spirits are shown holding ripe fruit and vegetables. Sometimes they are "brought to life" by a **shaman** blowing into their mouths or holding them over incense smoke.

In Puebla and Veracruz, people cut brightly colored tissue and metallic paper into **intricate** designs. A very sharp chisel, a hammer, and a razor are used to mark and cut out the patterns. Then these lacy papercuts are hung around the town or used to decorate the outside of churches on special occasions.

Papier mâché

In Mexico making things out of papier mâché is a very skilled art form. It was invented by the Chinese, who also invented paper. By the end of the 10th century, paper was more popular in Spain than the **papyrus** they had been using. Since paper is quite a cheap material and easy to obtain, you can find papier mâché artists all over Mexico making all sorts of amazing objects.

In other parts of the world, plastic is often used to make toys, but in Mexico quite elaborate toys are still made out of papier mâché. Puppets, masks, dolls whose arms and legs move, and rattles for babies are all made out of paper.

◆ How is it made?

Papier mâché is made by sticking layers and layers of wet paper onto a frame, which is usually made from chicken wire. Sometimes balloons or clay pots are used as the frame. When the paper has hardened, the balloon or pot can be broken, leaving just the shell of the papier mâché. This all takes a lot of time and work, but the results are well worth it. When the papier mâché is hardened, it is ready to be decorated.

These hand puppets for sale in a market are made from papier mâché. Giant papier mâché puppets called *mojigangas* are paraded down the streets during carnivals and festivals.

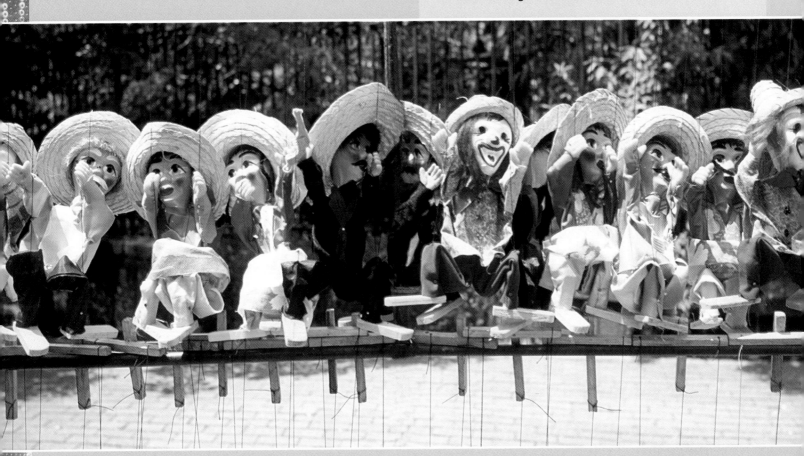

Toys and celebrations

All sorts of things are made out of papier mâché for children during religious celebrations. The week before Easter is an important time for Mexicans. During this holy week, paper workers in Mexico City and Celaya spend all their time making papier mâché Judas dolls (named after Judas Iscariot, a follower of Jesus who betrayed him). These come in many shapes and sizes and are meant to look very frightening. They can look like grinning devils painted red, skeletons, and sometimes popular characters. Traditionally the Judas dolls would have fireworks attached to them and be set alight in the streets on Easter Saturday. The Day of the Dead is another popular time for papier mâché skeletons and skulls.

Piñatas

At Christmas time and on birthdays, children in Mexico enjoy a special treat. A **piñata** is a special clay container that is filled with toys, candies, fruit, and nuts, and then covered in layers and layers of papier mâché. All sorts of shapes are made—stars, fish, flowers, small boats, and even Donald Duck and Batman can all be made from papier mâché. At the end of the feast, the *piñata* is hung up and the children are blindfolded, spun around, and given a stick to try and smash the piñata. When the *piñata* breaks, all the children scramble for the candy and toys. The custom began about 500 years ago in Italy. At parties the host would fill fragile, pineapple-shaped pots (called *pignatte*) with treats for their guests. *Piñata* parties soon became popular in Spain, and the custom was brought to Mexico by the Spanish settlers.

Breaking the *piñata* is a special treat enjoyed by Mexican children.

Music and Musical Instruments

Mexico is a country full of music. Wherever you go, you will find musicians on street corners, in bars and restaurants, and in people's homes, singing traditional folk ballads and making music. This is particularly the case during festival times, when bands and orchestras tour the streets dressed in traditional costumes. Mexicans also like to make their own musical instruments, and different regions of Mexico are famous for producing certain instruments.

Instruments from different regions

In the Sierra Madre mountains of Mexico, there is a town called Paracho, which is known as the guitar capital of Mexico. Almost everybody who lives in the town is involved in some way with the building of guitars. People come from all over the world to hear and buy these guitars, since the sound that they produce is so good. The reason they are unique is that, unlike many guitars, the ones from Paracho are made by hand from start to finish. A variety of simple tools are used, the most useful being the *cuchillo,* a type of sharp knife used by all the guitar makers to cut the wood. Different types of wood are used on the front, back, and sides of the guitar, each one creating a different sound. One of the most popular woods is Mexican rosewood.

Veracruz is famous for its harps and harp music. Like the guitar, the harp is a very popular instrument during festivals, particularly the religious ones. The *arpa veracruzana* is the folk harp made in this area. It has between 32 to 36 strings that are made from animal gut, and the harp measures up to 5 feet (1.5 meters) high.

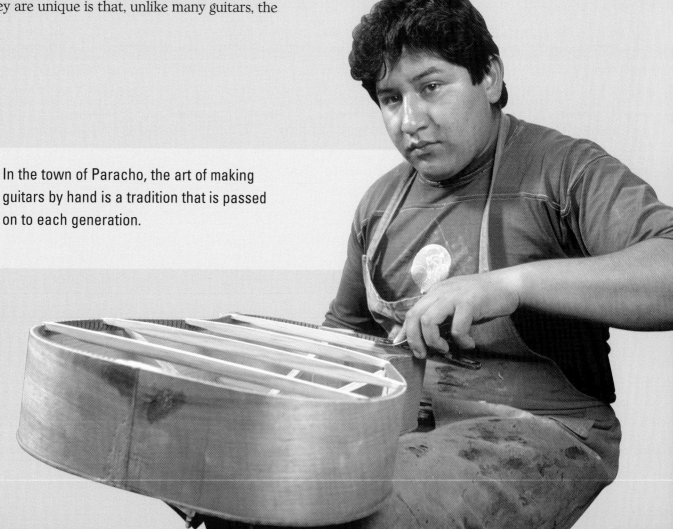

In the town of Paracho, the art of making guitars by hand is a tradition that is passed on to each generation.

Strolling bands

The folk harp is usually played with other stringed instruments by the strolling musicians who move from table to table in bars and restaurants singing songs for the customers. These groups are called **mariachi,** and they usually consist of two violins, two guitars, a *guittarón* (a large bass guitar), and often a pair of trumpets. All the musicians are expected to sing, and often they improvise or make up the songs to suit their customers, charging their customers for each song. Mariachi bands can be found all over Mexico, but they originate from Jalisco. They are easy to spot by the traditional costumes they wear: the wide-brimmed Mexican hat and a tight-fitting suit with silver buttons down the front.

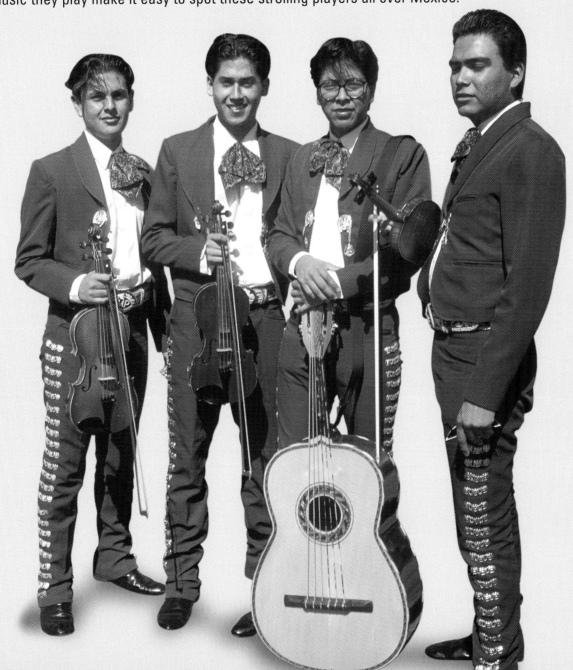

The flamboyant costumes worn by the mariachi musicians and the vibrant music they play make it easy to spot these strolling players all over Mexico.

47

Cross-Currents

In towns along the Mexico-United States border, the cross-currents of the two countries' cultures have led to many snack vendors' selling food and drink from both countries.

In the north, Mexico borders the states of California, Arizona, New Mexico, and Texas. It is in these states in particular that we can see the influence that Mexican art has had on art in the United States.

Mixing cultures

Some Mexican people, known as migrant workers, travel to the United States to work. This mixing of the cultures has caused Mexican art to become popular with many people in the United States. Papier mâché and silver jewelry are particularly popular. Tijuana in the north of Mexico is a very popular vacation destination for many Americans, and a lot of silversmiths work in this town.

International tourism has led to an increase in the popularity of Mexican art in other countries, too. Places like Cancún and Acapulco attract visitors from around the world, and Mexican art makes great souvenirs.

The festival of Cinco de Mayo is probably more popular among Mexicans who live in the United States than it is in Mexico, perhaps because these people are away from home and feeling nostalgic about where they were born. On this day, many people in the United States eat Mexican food and dress in traditional Mexican clothing, and children will break open a *piñata.*

Famous artists

The artists Frida Kahlo and Diego Rivera have had a great influence on art in Europe and the rest of the world. They were both inspired by folk art and the art of the ancient civilizations, and they included aspects of these traditions in their paintings. When they became famous and their work became known around the world, Mexico and its history were introduced to people who until then probably knew very little about the Mexican way of life. Kahlo was famous for wearing traditional Mexican dress and a lot of **pre-Hispanic** jewelry. When she was seen in the fashion magazine *Vogue* wearing a Mexican ring on every finger, it started a trend among jewelry designers, who began to copy Mexican-style jewelry.

Tina Modotti was born in Italy in 1896, but she moved to Mexico and worked as a photographer. She became a **communist,** and her photographs are famous for their revolutionary images of working-class Mexicans and Mexican **artifacts** such as an ear of dried corn, a sickle, and a guitar.

Francisco Toledo is a contemporary artist who was born in Oaxaca in 1940. He worked in Paris for awhile, but when he returned to Mexico he dedicated himself to the promotion of the traditional arts and crafts of his home state, Oaxaca. He expresses his art in many ways, including tapestries, pottery, sculpture, and painting. He is well known for being not only an exceptional artist, but also someone who wants to protect the native traditions of Mexico.

In the 20th century, for the first time in history, Latin American art became famous around the world. Collectors and museums wanted to buy artwork such as the paintings by Mexican artist Rufino Tamayo. His work was influenced by pre-Hispanic art as well as more modern European styles.

Frida Kahlo's dramatic life has provided fantastic material for a successful Hollywood film about her life and work. Here, the actress Salma Hayek, herself an example of the success of Mexican artists and performers in the United States, waits on the set of the film she produced and starred in about Kahlo's life.

◆ Mexican music

Traditional *mariachi* music has become commercialized in Europe and the United States. "La Bamba" was originally a traditional Mexican folk song with improvised verses. It became an international hit in the 1950s and then again in the 1980s. Although the tune is the same, the words bear little resemblance to the original folk version.

Influence from abroad

For many years the native people of Mexico have been carrying on the traditions of their ancient ancestors and making art and crafts by hand. However, today it is becoming increasingly difficult for **artisans** to continue working in this way. The pace of life is changing in Mexico and more and more people are using machines to make things, since this is a lot less time-consuming and allows them to have more to sell.

Plastic and nylon

Where once people used natural materials that they found locally, today natural materials are in many cases being replaced with **synthetic** materials such as plastic, a material that can be easily molded using machines. Many pots that used to be made out of clay are now made out of plastic. In many villages nylon dresses that are made by a machine are replacing the beautiful hand-woven *huipiles* with their embroidered designs. This is partly because women prefer to wear a more modern style of dress.

The **lacquering** of **gourds** is another example of a traditional craft that is dying out. Traditionally, gourds are lacquered by hand, and it takes many days to build up the layers of lacquer. The effect is very beautiful, but it takes a long time. More and more workers are using artificial gloss paints instead, since this is much quicker and more profitable.

Using machines to make things instead of crafting something by hand means you can produce larger quantities in less time and make more money. However, the objects are not as individual as those that have been handcrafted.

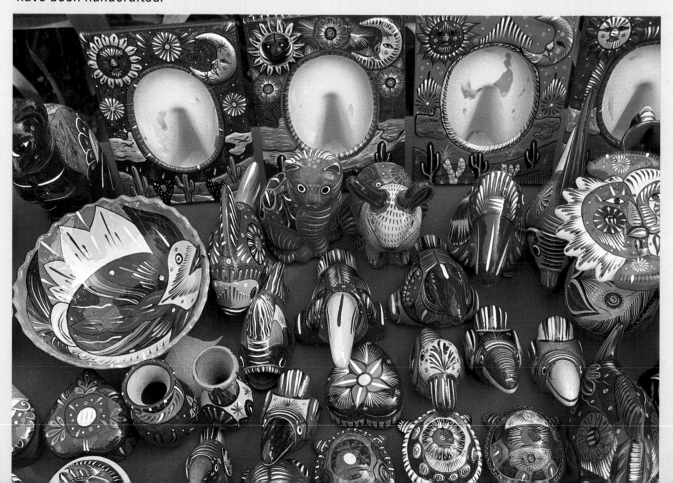

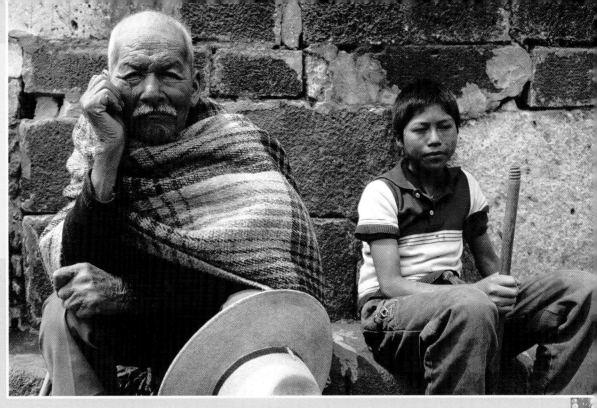

This young boy and his grandfather illustrate the variety of clothing found in Mexico today. Both traditional and modern styles are widely worn.

Television, advertising, and movies

Ancient traditions are also dying out because children are reluctant to learn the skills from their parents. Television has allowed people to see what is being done in other countries, and this often means that they no longer find the more traditional way of life appealing. This trend is leading to a decline in the popularity of the handmade toy market. Children who live in the cities know all about cars and computer games and are not interested in simple toys like the pottery whistles that entertain village children. Today, handcrafted toys are largely made by elderly people who make little profit. Their descendants are not likely to carry on the tradition.

Advertising is also responsible for the gradual disappearance of some traditional crafts. In many parts of Mexico, Santa Claus and Christmas trees, traditions that started in Europe, are now being adopted by many Mexicans and are replacing traditional customs such as the clay nativity scenes. The influence of the movie industry has had a big effect on the things people like to buy, and characters such as Batman are more in demand than traditional cultural figures.

A richer culture

Throughout its history Mexico has been touched by many different cultures. While Mexico had strong traditions of its own, these different cultures have had a great influence on Mexican art. When the Spanish arrived, they brought with them particular methods of making things and special materials that could not be found in Mexico. The art of **filigree** became a popular craft in Mexico because it was very popular in Spain at that time. Before the conquest, craftspeople only used materials that were **indigenous.** Afterward, they imported things such as wax and lead from other countries. They adopted new skills from other countries, too, such as glass-blowing and making papier mâché.

The aim of most contemporary Mexican artists is to make pieces of art that have a strong Mexican flavor, but that include the styles of both **Native American** and Western art. The art that is produced in Mexico is very rich and varied because of the many cultures that have gone into making the country what it is today.

Further Resources

More books to read

Baquedano, Elizabeth. *Eyewitness: Aztec, Inca & Maya.* New York: Dorling Kindersley, 2000.

Barghusen, Joan D. *The Aztecs: End of a Civilization.* Farmington, Mich.: Gale Group, 2000.

Green, Jen. *Mexico.* Chicago: Raintree, 2000.

Kallen, Stuart A. *The Mayans.* Farmington, Mich.: Gale Group, 2001.

Tilton, Rafael. *Mayan Civilization.* Farmington, Mich.: Gale Group, 2002.

Websites

www.yahooligans.com/ arts_and_entertainment/Art/
Type in *Mexican* in the search box to find many great sites

www.mexicanmuseum.org/
A lively website that explores the complexity of Mexican and Latin cultures in the Americas

www.diegorivera.com/index.html
A website dedicated to the work of Mexico's most celebrated muralist, Diego Rivera

www.artcyclopedia.com/artists/kahlo_frida.html
A site with many links to artwork by and articles about Frida Kahlo

Places to visit

United States

International Folk Art Museum, Santa Fe, New Mexico

Mexican Fine Arts Center Museum, Chicago

Mingei International Museum of Folk Art, San Diego

Museum of Spanish Colonial Art, Santa Fe, New Mexico

Mexican Museum, San Francisco

Metropolitan Museum of Art, New York City

Taylor Museum, Colorado Springs

Tuscon Art Museum, Arizona

UCLA Fowler Museum of Cultural History, Los Angeles

Mexico

Museum of Modern Art, Mexico City

Museum of Contemporary Art, Monterrey, Mexico

Museum of Contemporary Art, Oaxaca, Mexico

National Anthropology Museum, Mexico City

National Museum of Art, Mexico City

Glossary

afterlife existence after death that some people believe in

aqueduct bridge that carries water across a valley

archaeologist somebody who studies history by digging up and examining remains in the earth

artifact object that has been crafted

artisan craftsperson

basalt dark volcanic rock

caricature cartoon drawing of somebody that exaggerates his or her features, often to make fun of the person

cast when molten metal is poured into a mold to produce a certain shape

caste division in society based on differences such as wealth, occupation, or race

causeway raised road or track above low ground or a stretch of water

codex (plural **codices**) ancient picture writings of Mesoamerica

colonial in Mexico, styles and culture that came from Spain

Colonial period period in Mexico between about 1520, when the Spanish conquered indigenous cultures, and 1821, when Mexico won its independence from European rule

communist person who believes in the political ideas of Karl Marx, who advocated the elimination of private property and a government that controls all aspects of production

conquistadors Spanish explorers who conquered the Aztecs and the Maya

criollos white Mexicans who were descended from people in Europe

Cubism early 20th-century artistic movement that represented objects in a fragmented, geometric way, rather than in a realistic way

Expressionism early 20th-century artistic movement in which an artist considers expressing his or her feelings more important than representing reality

filigree technique that involves twisting fine gold or silver wire into delicate patterns

fire in ceramics, the process in which clay is heated up to a very high temperature and turned into pottery

fresco painting on a wall or a ceiling done while the plaster is still wet

glaze to fix a special type of paint on pottery in order to create color and/or a shiny surface

gourd fleshy fruit or vegetable with a hard skin that is dried and can be used as a drinking vessel

Huichol traditional group who live in the Sierra Madre, a mountainous area in one of the remotest parts of Mexico. They are very cut off from the rest of the country and still worship ancient gods.

icon image that inspires worship

indigenous somebody who was born in a specific country or region; materials from that region

inlaid when one material has been used to fill another, so that both surfaces are flat

intricate complicated, detailed, and delicate

lacquer to apply a substance that, when it dries, becomes a shiny, hard protective coat

La Danza de los Concheros complex form of performance that is rooted in part in ancient Aztec traditions. It combines elements of dance, music, theater, and poetry, and its meaning is essentially spiritual.

Lancandón native Mexican group whose religious beliefs and practices have been inherited from the Maya

lintel piece of timber that sits horizontally at the top of a door frame

majolica earthenware with colored patterns on white enamel tin

mariachi popular Mexican strolling bands of musicians, which usually include two violins, two guitars, a large bass guitar, and a pair of trumpets

mestizo people of mixed European and Native American ancestry who make up about 60 percent of the population of Mexico

Modernism early 20th-century artistic movement in all the arts that strove to break from traditions and styles of the past

mosaic form of surface decoration made by laying down small pieces of colored material, such as glass, to form an image or pattern

motif distinctive feature or ornament that is easily identified

mural decoration painted or carved on a wall

Native Americans peoples and their descendants who lived in the Americas before the Europeans arrived

obsidian dark, glassy volcanic rock that is extremely hard

ornate having a lot of decoration

Otomí traditional group who live chiefly in the state of Mexico and in central Hidalgo. Most of the people are Catholic, although some in the village of San Pablito still honor the ancient gods.

pannier basket, usually one of a pair, that can be carried over the back of a mule

papyrus type of paper that is made from the stems and stalks of a papyrus plant

pendant jewel or other decorative object that hangs on the end of a necklace

peninsula piece of land that juts out into a sea or lake so that it is almost completely surrounded by water

pigment part of a dye or paint that produces its color

pilgrimage religious journey to a certain sacred place

piñata treat for children during festivals. Candy and toys are hidden in a clay pot that has been decorated with papier mâché. The children are blindfolded and then try to break the pot with a stick to release the treats inside.

plaza central open square in a city

poncho simple garment that resembles a blanket with a slit in the top for a head

pre-Hispanic anything that existed before the Spanish arrived in the Americas about 1520

renaissance means "rebirth"; used to describe anything in art that is a new way of doing something. When capitalized, it is particularly associated with Italy in the 14th–16th centuries, when artists such as Michelangelo and Leonardo da Vinci began to make art in a new way.

renowned well-known or famous

ritual act performed in a certain prescribed order

rosary string of beads that Roman Catholics use to keep count of the number of prayers they have said

shaman person who is thought to be in touch with the spirit world

solstice time when the sun is farthest from the equator. This occurs once in the winter (the winter solstice) and once in the summer (the summer solstice).

sophisticated something or somebody that is quite complicated and highly developed

spindle small bar that can be used by hand to wind and twist thread

symmetrical exactly the same on opposite sides

synthetic something that has not been made out of natural materials but out of human-made ones

tortilla thin, round, flat cake made from maize or corn meal and baked on a flat stone. It can be eaten with meat, chilies, or beans.

Western Hemisphere half of the earth containing the Americas

Zapotec traditional group that lives in Oaxaca. Their language is divided into many dialects. They make very fine pottery and serapes made on treadle-looms. The women are famous for their extravagant clothing.

Index